# The Alhambra of Granada

PATRONATO DE LA ALHAMBRA Y GENERALIFE

TRIANGLE▼POSTALS

# The Alhambra of Granada

❖

photographs by **Lluís Casals**

❖

texts by **Félix Bayón**

❖

© 2000:    **Patronato de la Alhambra y Generalife.**
**Consejería de Cultura. Junta de Andalucía.**
**Triangle Postals S.L.**

© Photography:    **Lluís Casals**
© Text:    **Félix Bayón**

Graphic design:    **Joan Barjau**

Description of de photographs:    **Jesús Bermúdez**
Translation:    **Steven Sylvester**
Acknowledgements:    **Mohamed Buaziz**

Colour separations:    **Tecnoart**
Printed by:    **Industrias Gráficas Viking S.A.**
Paper:    **Creator Silk 150 g/m$^2$.Torraspapel S.A.**

Depósito legal:    **B: 32.853-2000**
ISBN:    **84-89815-81-X**

# Index

*To my children* —Lluís Casals—

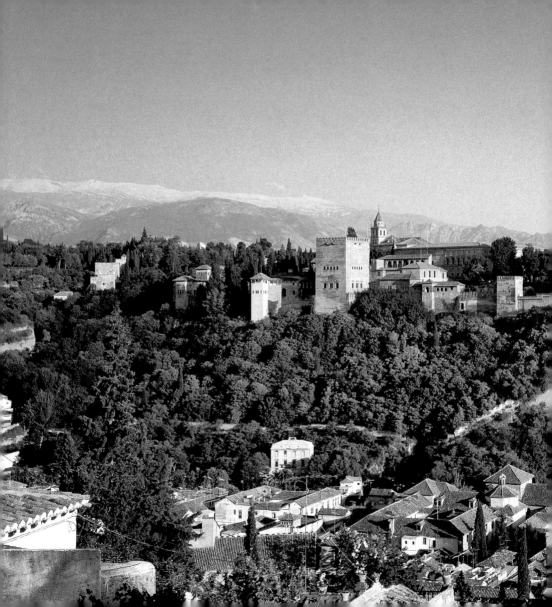

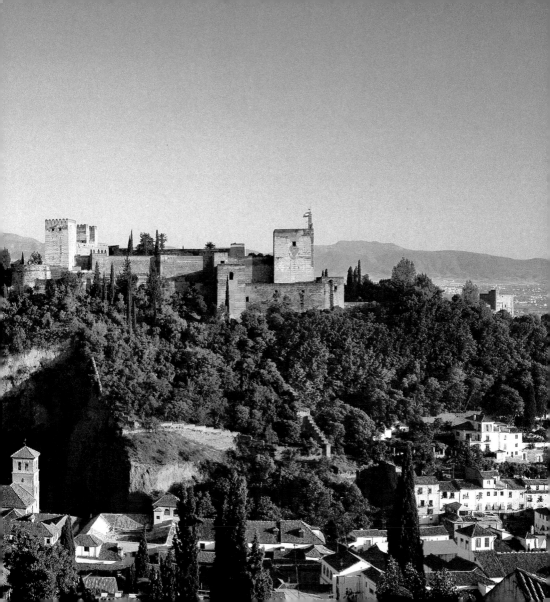

# The Fragile Red Fortress

قصر الحمراء

Those who built the Alhambra could hardly be accused of showing off. The fortress constructed on the clay hill whose colour gives it the name of *Qal'at al-Hamra* – Red Fortress – is an accumulation of modest materials: stones, pebbles and bricks. Neither did those who gave form to the palaces inside the precinct seem obsessed with leaving future generations in awe. The elements used in its construction condemned the Alhambra to a short-lived existence. With tiles, stucco, plaster, bricks and wood, works of great beauty were obtained, but this was no guarantee to permanence. The Alhambra is almost a metaphor of life in the Nasrid kingdom which gave rise to its existence: it is the fortress of a beseiged monarchy whose fall was not an obstacle, but rather a motivating force to the rich work of poets, artists and scientists. A kingdom which was more interested in beauty than in perpetuity. The palaces were not built for eternity. Not even for the enjoyment of heirs.

In a cruel, intriguing world, the sovereigns were not too worried about the legacy they were to leave. Plaster and stucco was superimposed on that left by earlier sultans and one palace was attached to another, following the same pattern of disorder visible in the small aristocratic, administrative city which formed around it. As in the city at the foot of the Alhambra, the façades were not important. The houses of the rich and the poor were similar: narrow allies led to each, and only inside, in the central courtyard, were they different. The rich decorations of the interior were protected from the eyes of onlookers. Only very few – a few thousand – were allowed access to the inside of the Nasrid palaces that now receive the visit every year of more than two million people. The secret beauty of these places would certainly have left the Christian conquerors in awe when they captured the city in 1492. The Catholic Monarchs entreated the custody of the place to a family of nobles. Thanks to the conquerors who boasted of their quarry, making it their trophy, the Alhambra can still be observed today. But universal interest in this monument is a phenomenon of hardly two centuries old. It begins in the nineteenth century, when the Romantic travellers "discover" the treasures of the Alhambra. In their eyes, the discovery is even more exotic due to the presence of gypsy families in some remote corners of the precinct. They could not wish for more: the exotic flavour of the East and the typical character of the South enclosed within the same walls. Chateaubriand, Washington Irving, Théophile Gautier and Víctor Hugo direct their attention, in various degrees, to this precinct and its history. Since then, the Alhambra has been observed through the eyes of the Romantics. The pictures in this book afford the visitor a contemporary view of the precinct.

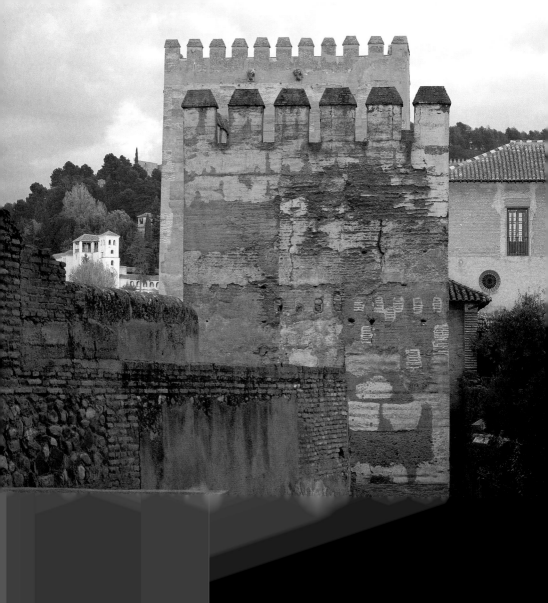

# The last symbol of power

The fortress of the Alhambra is the last symbol of Muslim power in the Iberian Peninsula, a power which increased its scientific and cultural hold as its military strength was weakened. In just over twenty years, the Arab troops which in 711 had crossed the Strait of Gibraltar reach the French city of Poitiers. But only when the military muscle begins to slacken, Islamic culture becomes richer. Cordoba under the Ommaid dynasty, from the eighth to the eleventh century, is a cultured, tolerant society in which various languages and religions live together. Even in the twelfth century, under the reign of the intolerant Almohads, there lived in the city scholars such as Maimónedes and Averroes. A hundred years later the definitive retreat takes place. The Christian armies of Castille, Aragon and Navarre defeat the Almohad forces at Las Navas de Tolosa, the gateway to what is now called Andalusia. From then onwards, Muslim power begins to disintegrate. Court intrigues begin to confront different chiefs, whilst the Christians continue to advance. On Friday 12th April 1232, at the end of the weekly prayers in the small mosque in the village of Arjona, near Jaen, Muhammad ibn Yusuf ibn Nasr is proclaimed sultan, known later as Ibn al-Ahmar. This is only one more sign of the disintegration of Muslim power. But this time the event will be of particular importance thanks to the skill and diplomacy of this man who claimed to be the successor of a disciple of the prophet Mahoma. Ibn al-Ahmar increases his power until, in 1238, he becomes the first Nasrid sultan and the only Muslim governor in the Iberian Peninsula after swearing allegiance to King Fernando III. In this way the kingdom of Granada is born, reigned by a dynasty which is weak in military terms and financially burdened by the tributes it must pay to the Christian Monarchs. However, this dynasty will survive two and a half centuries more until it finally falls in the seige which cuts it off from the north of Africa. In Granada, the nobles act as patrons to artists and poets, agriculture is developed and the merchants and craftsmen continue to supply the customers they have acquired all over the Mediterranean. The ruined fortress which Ibn-Ahmar finds on coming to power will be transformed from then on into the most important legacy of Muslim Spain.

*← Tower of the Hens; behind it, the Comares Tower*

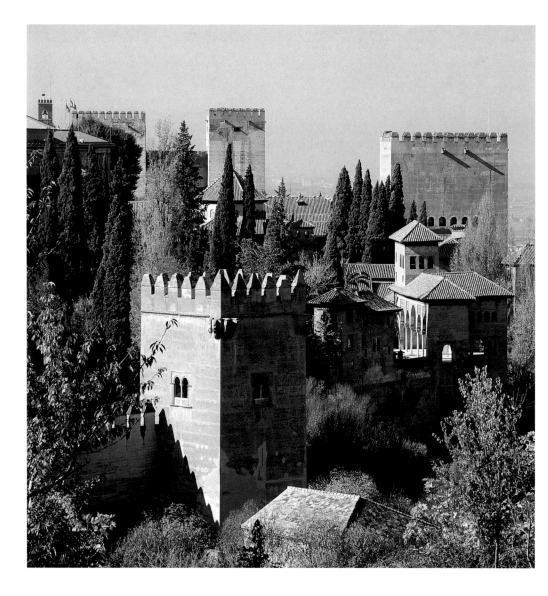

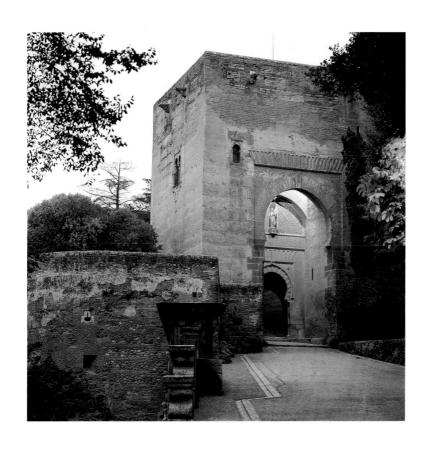

*The Justice Gate* ⇡
⇠ *Tower of the Spikes (13th century to 15th century)*

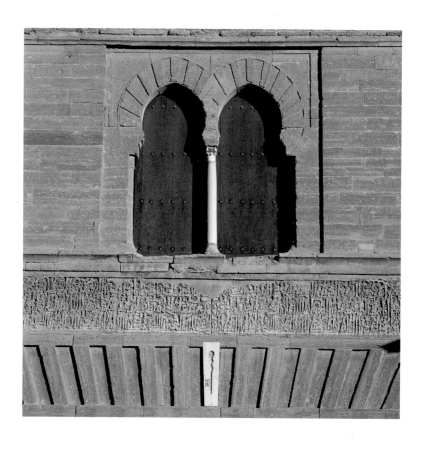

*The Wine Gate*

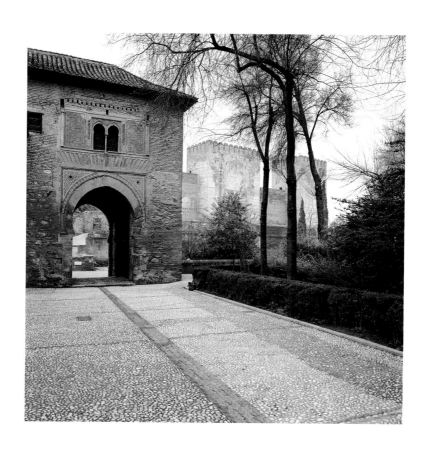

*The Wine Gate*

# The warriors´den

The warriors had their own world in the Alhambra. At the eastern tip of the precinct, in the form of a spearhead, is the citadel. It was here that the first Nasrid sultans probably lived, before work was begun on the palaces. There was already a fortress here when Ibn-al Ahmar took Granada. It is even possible that the castle existed before the Arabs came over to the Iberian Peninsula. But it was the Nasrids who erected this fortress, whose remains evoke a suspicious, hierarchical world. The fortress and the palaces are completely separate, as if the nobles had decided to live behind the backs of the warriors. Inside the fortress, which was used exclusively for military purposes, the excavations reveal two distinct areas separated by a central alley. On one side, to the north, are the remains of small rooms where the officials were housed. On the other side, there were other bigger rooms which were used as weapon stores and housing for the troops. The fortress was also the most sordid area of the Alhambra. All through its history, its different inhabitants have used it as a prison.

Here there were half a dozen dungeons from which it must have been difficult to escape. Dug into the ground, they were shaped in the form of a bottleneck: a very narrow entrance which became wider as it penetrated underground. It is probable that some of the dungeons were used also as stores for grain, spices and salt. The fortress has also been the main point of reference for the Granadine people. At the tip is the Watch Tower, the place from which the town below can be observed. It was here that the Christians, with due ceremony, celebrated the capture of the kingdom of Granada on the 2nd January 1492. Reports state that on their arrival the Christians found nobody inside the Alhambra. Cardinal Mendoza climbed to the top of the tower holding the cross of Christianity and waving the royal banners and the standard of Santiago in the name of the Catholic Monarchs. The Christians ordered the setting up in this place of a bell whose peals have controlled life in Granada ever since. The bell in the Watch Tower has sounded the alarm in times of danger and has rigorously controlled the passage of time for almost five centuries.

←·· *The Homage Tower*

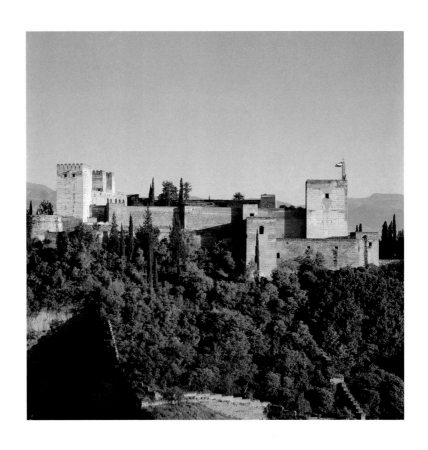

*The Fortress (11th to 16th century)* ↑
*The Arms Gate* ⇢

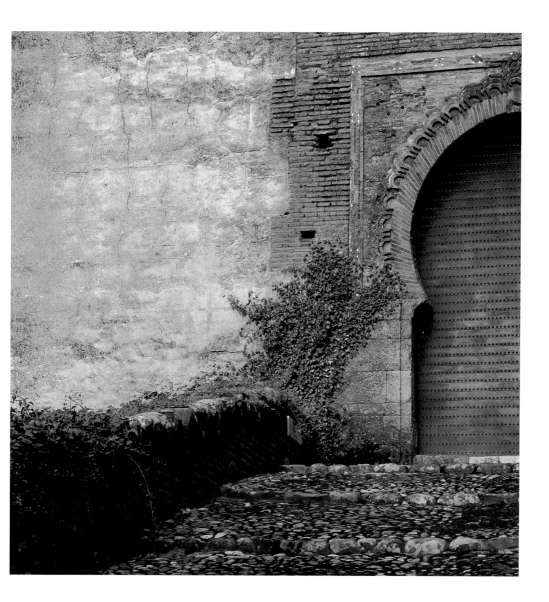

*The Homage Tower*

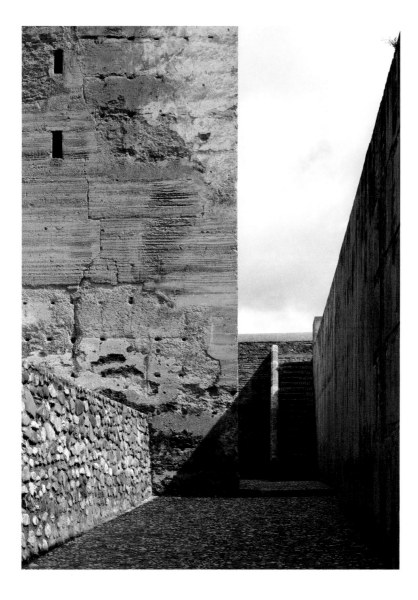

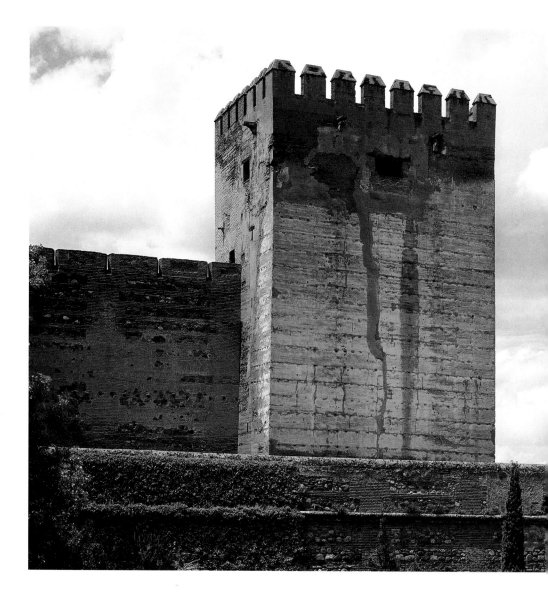

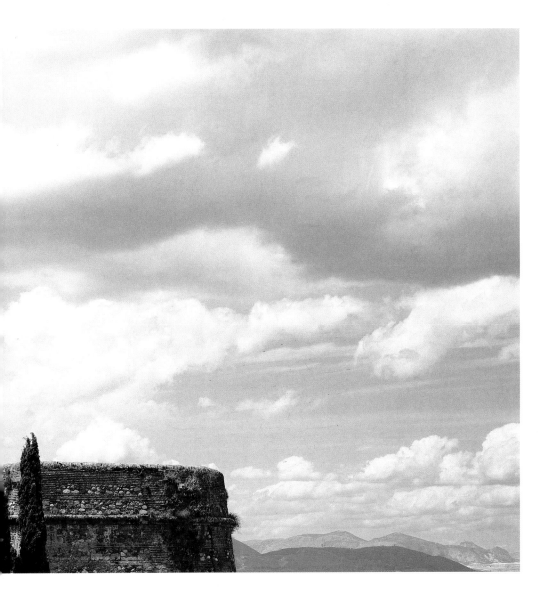

*Northern Wall of the Fortress*

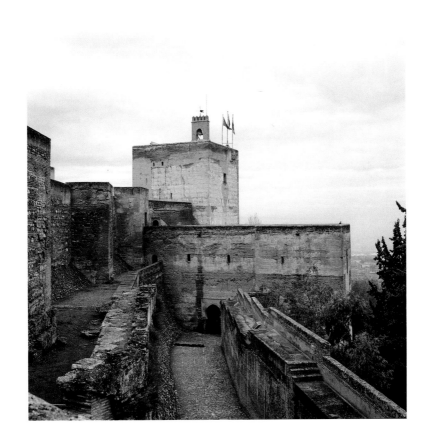

*Main entrance from the Arms Gate*

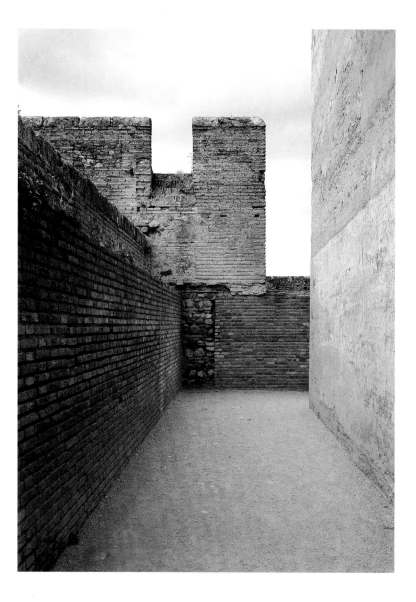

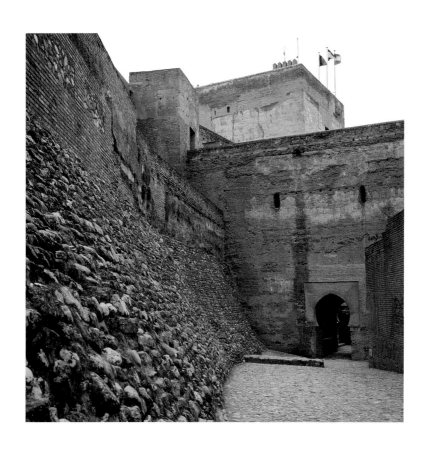

*The Arms Gate* ⇑
⇐ *Barbican of the Fortress*

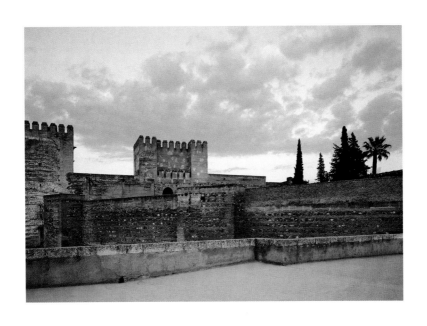

*The Fortress from the terrace of the Arms Gate* ⬆
*Walkway of the curtain wall* ⋯➔

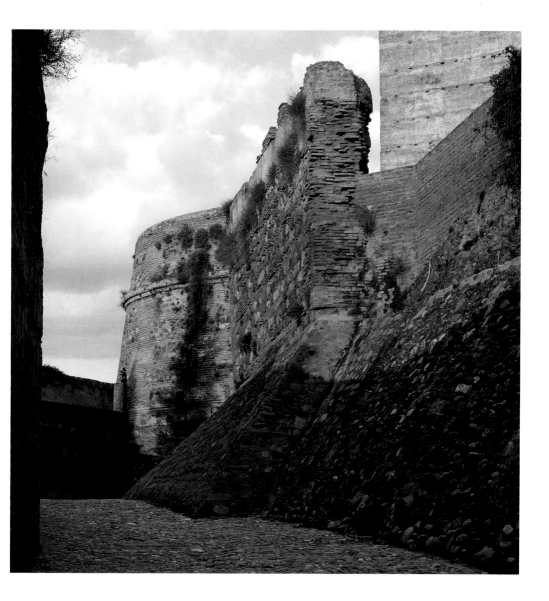

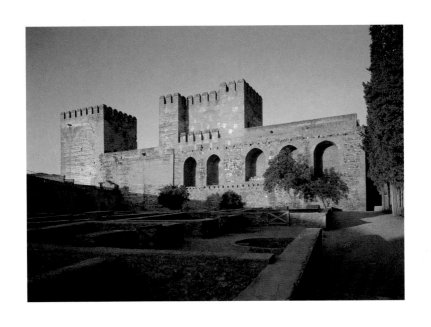

*The Fortress. The Arms Gate (14th century)* ⬆
*The Broken Tower (14th century)* ⋯➤

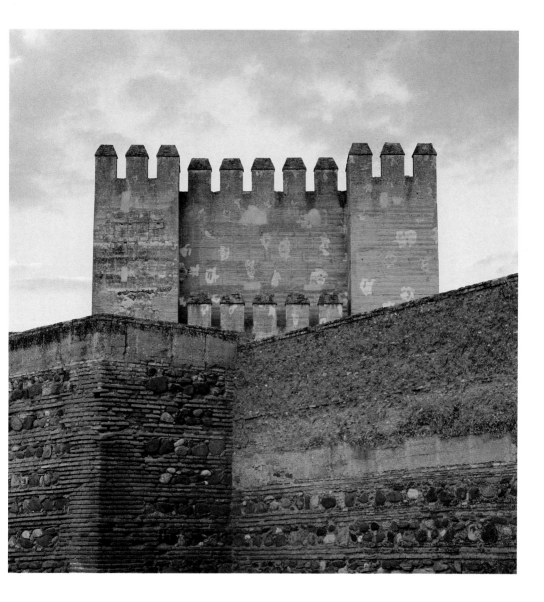

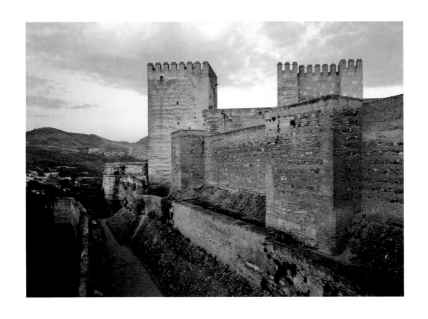

*Fortress, northern side*

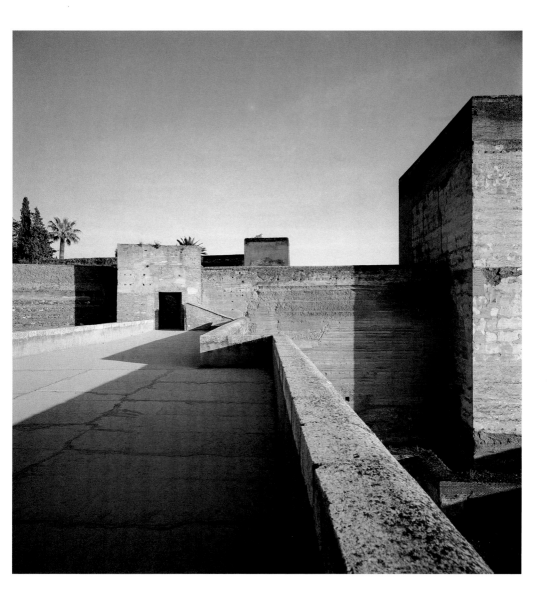

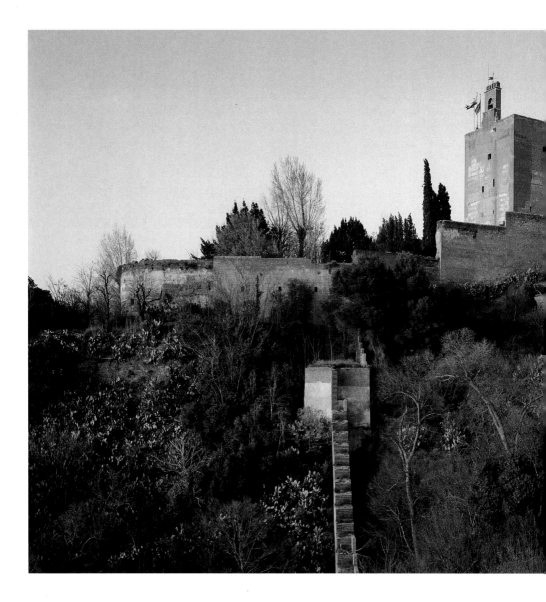

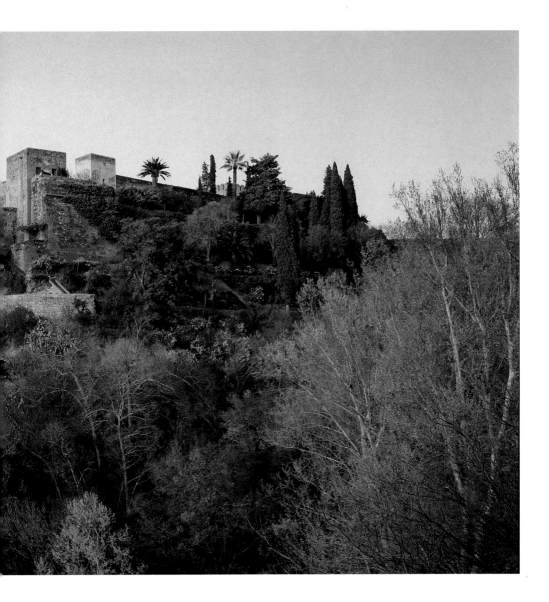

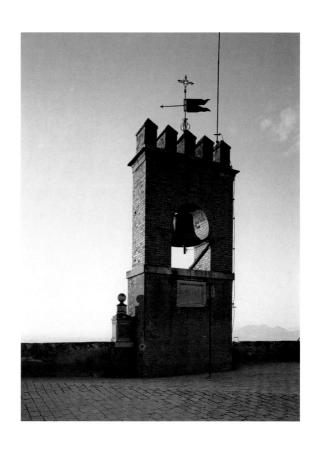

*Belfry of the Watch Tower* ⬆
*The Watch Tower* ⇢
⇠ *The Fortress on the southern flank*

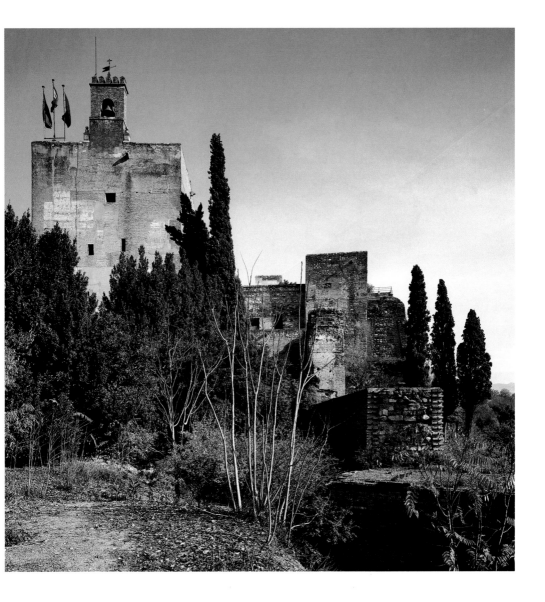

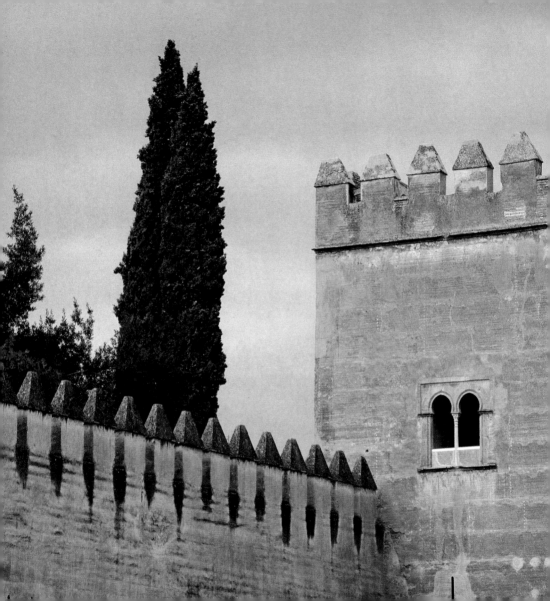

# The kingdom of distrust

The outside appearance of strength of the Alhambra is deceiving. In no way does it correspond to the world that created it. The Nasrid kingdom was in no way solid. Twenty-three sultans reigned Granada in the 254 years that elapsed between the time when ibn al-Ahmar captured it and when the Christians took it over. Not even the periods of more apparent stability are free of tension, as when, during the fourteenth century, Yusuf I and Muhamad V reigned, the latter reigning for two periods of a total of 34 years. But it is above all at the end when the Nasrid kingdom reveals its complete political disintegration. In the 15th century twelve sultans reign, and some of them reign on four different occasions. In this way it can be seen that the Alhambra was not only designed as a defence from the outside but also from within. To the north of the precinct, a long passage runs through the inside of the walls: it is the patrol route, the passageway used by the guards who defended the surrounding palaces. It is a kind of enormous moat which is linked to the fortress but which, on the other hand is separate from the palaces.

It is without doubt the bastion on which the last line of defence was established in the case of a seige, but it is also an indication of how the sultans defended themselves from their own guards with as much zeal as they would from the enemy. The gates of the palaces are made in the same way as those separating the Alhambra from the outside. There is no direct route into the inside. The visitor is always confronted by at least one wall forming a bend that one has to go round in order to penetrate into the interior. This turning serves as protection against an invasion, a mob, an unguarded look. The patrol route is the last trench, but not even from here can the secrets of the Alhambra be discovered. The towers and the walls on the northern side, which appear quite solid from below, are a great metaphor. From outside they only seem to form a fortress, an enormous shield which endeavours to save the last Muslim enclave in the Iberian Peninsula from disappearance. Very few could have known then the beauty which was hidden inside these walls, a beauty which even invades the inside of the towers.

*←·· Tower of the Spikes (13th – 15th century)*

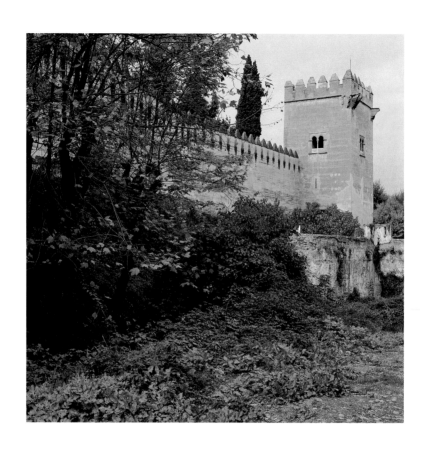

*Wall and Tower of the Spikes*

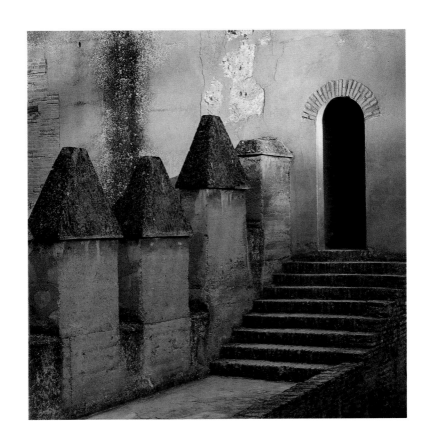

*Tower of the Judge*

*Northern wall of the Alhambra. Outside sector*

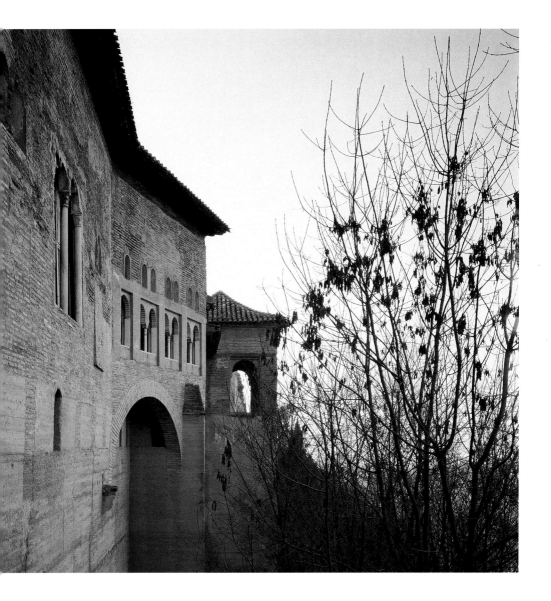

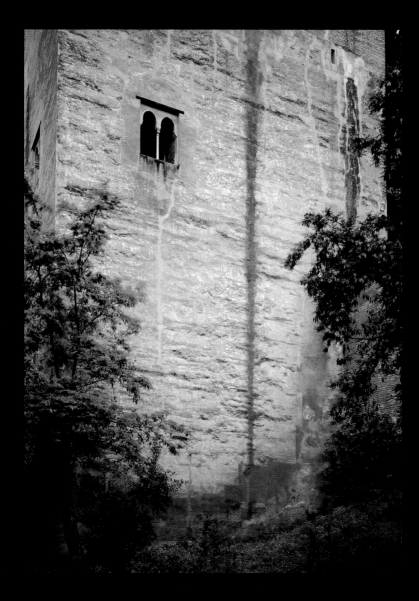

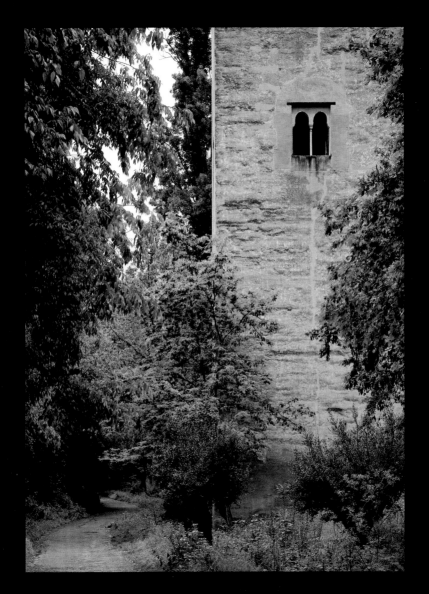

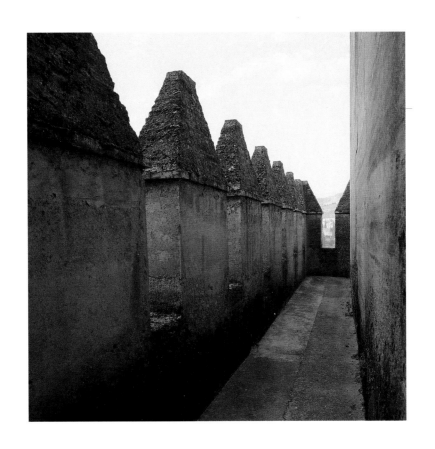

*Walkway along the battlements* ⬆
*Tower of the Hens* ⤐
⬸ *Tower of the Captive (14th century)*

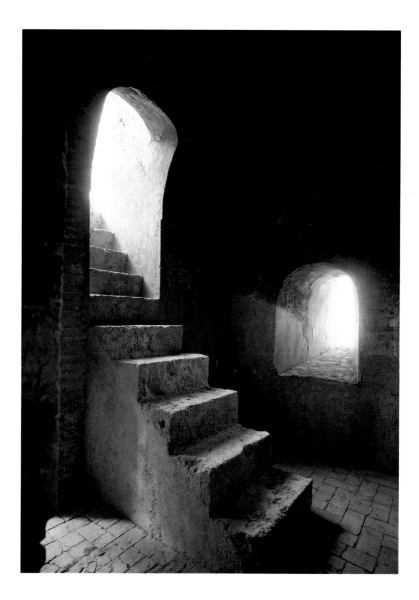

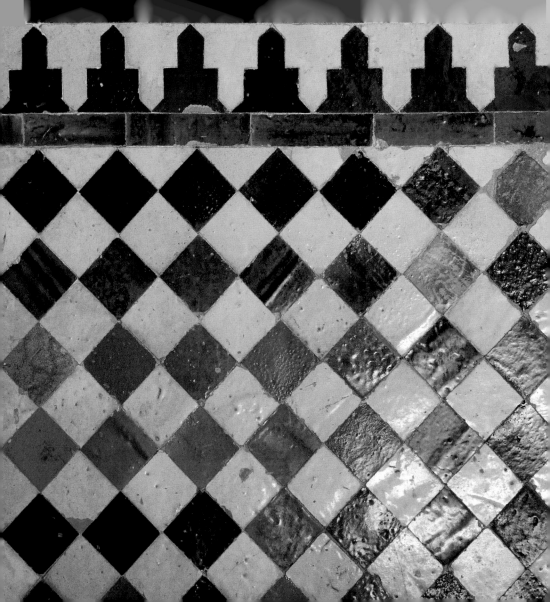

# The frontier of mystery

Few inhabitants of Granada would have been allowed to go inside the walls of the Alhambra. But inside the walls, the gates of the Mexuar conformed the final frontier. It has always been assumed that the main entrance to the palaces must have been here. In the small room which the Christians converted into a chapel, the Sura (the council of ministers) probably met. It was also the place used as the waiting room for the subjects of the kingdom who were waiting for the sultan to administer law. The current entrance to the Mexuar is not the original, but it is quite similar. Nobody must expect an ostentatious gate. The splendour of Islamic palaces was always inside, as can still be seen in the towns of Marraquech, Fez, or Meknes in Morocco. Today the Mexuar contains decorative elements taken over a period of time from different corners of the palaces. On a visit we can hardly imagine what it was like before the arrival of the Christians. Going on through the Mexuar the visitor is received by a fountain in the centre of the Cuarto Dorado (The Gilded Room). It barely gives any idea of what we can expect to see further on. Muhammad V,

the Nasrid sultan who managed to remain in power the longest, wished to establish here the final frontier of his privacy. To commemorate the conquest of Algeciras, in 1370, he ordered the inside façade of the palace to be decorated with plaster – at the time this was painted in bright colours – and protected by huge eaves. This wall in the courtyard of the Cuarto Dorado was the only indication of the hidden beauty which could be seen by people outside the Nasrid nobles: almost a vague illusion.

The boundary was formed by two doors behind which there were hidden turns: one of them leads outside again and the other gives access to the royal palaces, although not directly, but along a windy path, as if the inside was meant to be protected from intruders. Between the two openings was the throne from where the sultan gave orders to his administrators. Above the wooden framework which holds up the eaves, mysterious words indicate the symbolic nature of the double door. They are verses written by the vizier ibn Zamrak: "My position is that of a crown and my door is a junction; the West believes that the East is in me."

*←·· Gilded Room*

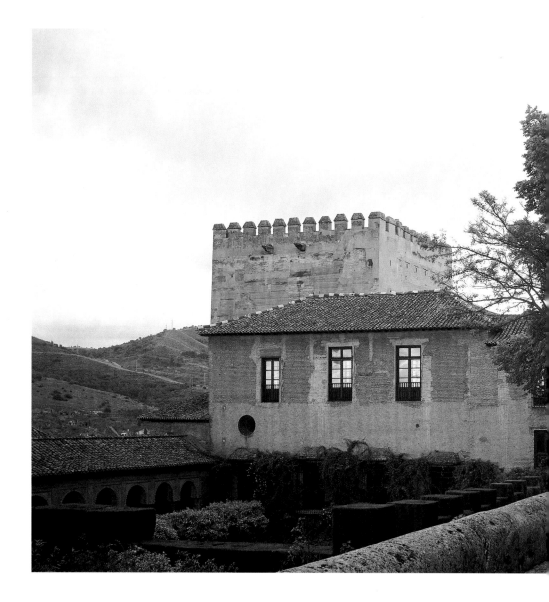

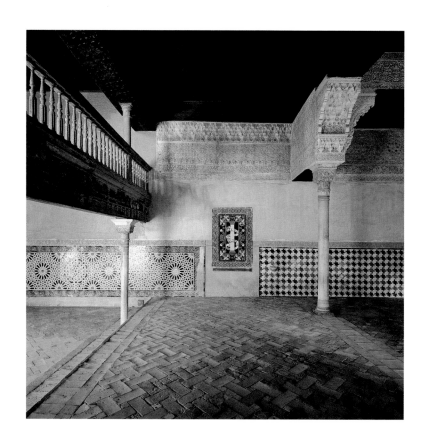

*Hall of the Mexuar* ⬆

*Balustrade of the Mexuar* ⸱⸱➔

⸱⸱⬅ *Forecourt of the Alhambra palaces*

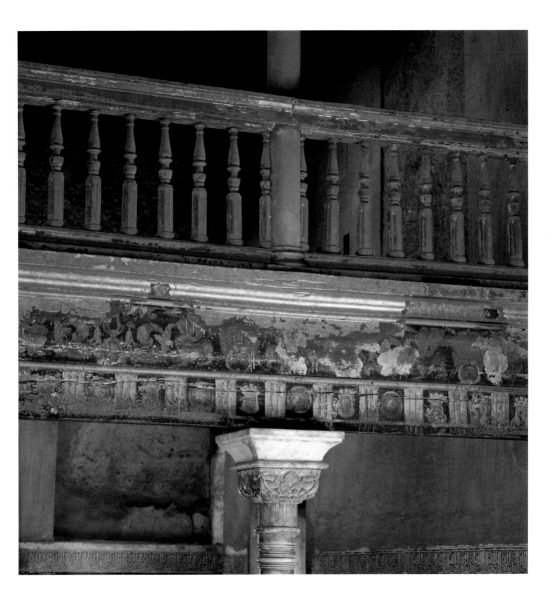

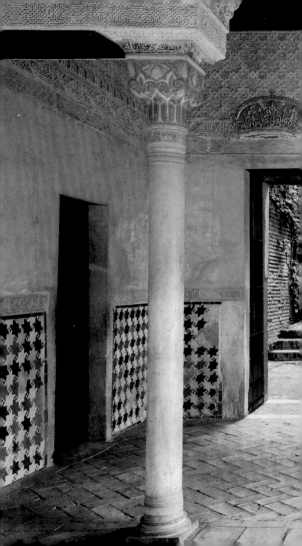

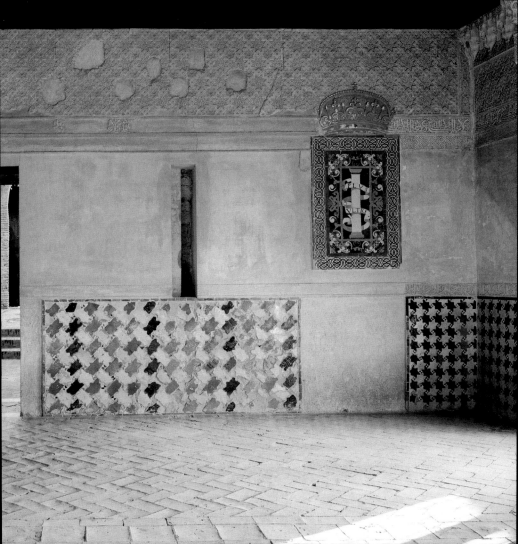

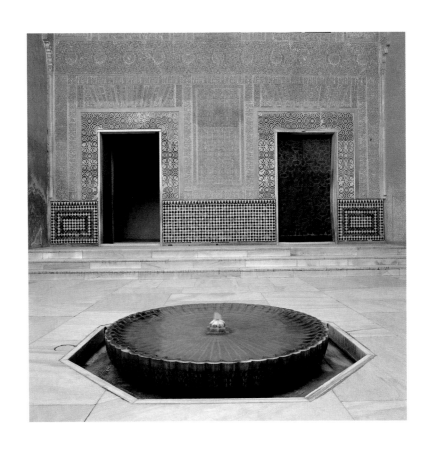

*Court of the Gilded Room* ⇡
⇠ *Hall of the Mexuar*

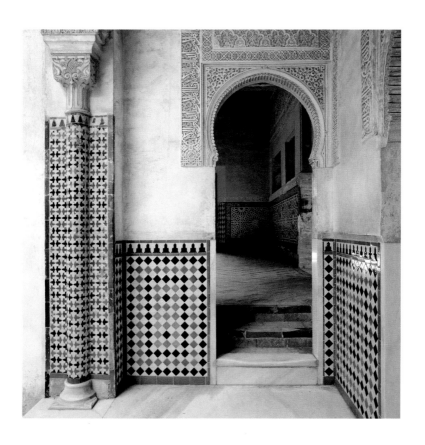

*Mexuar and Gilded Room*

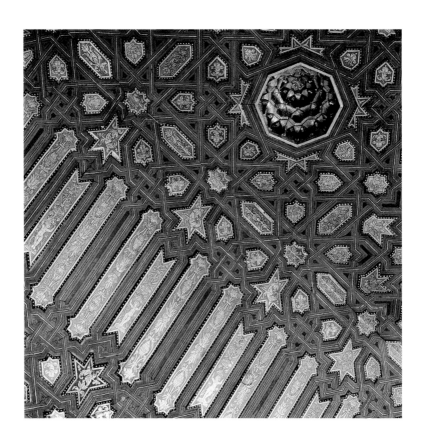

*Gilded Room*

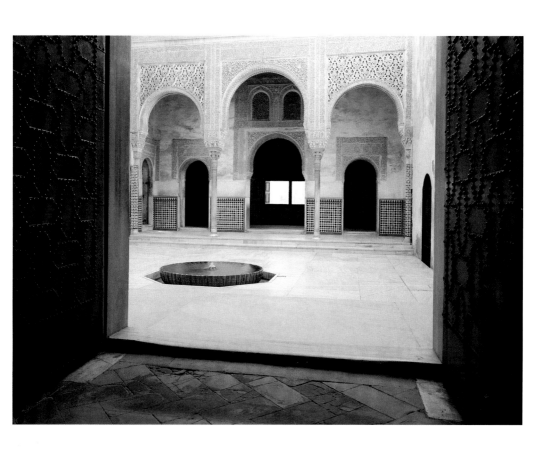

*Court of the Gilded Room*

*Court of the Gilded Room* ⋯→

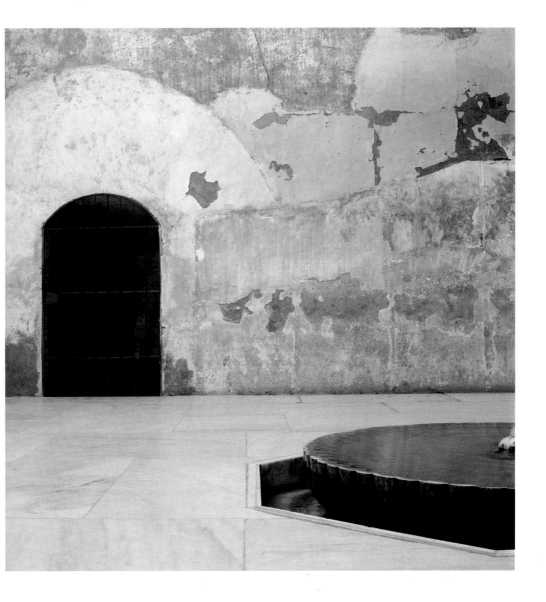

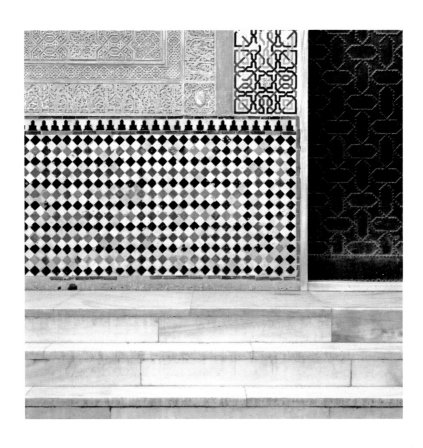

*Court of the Gilded Room*

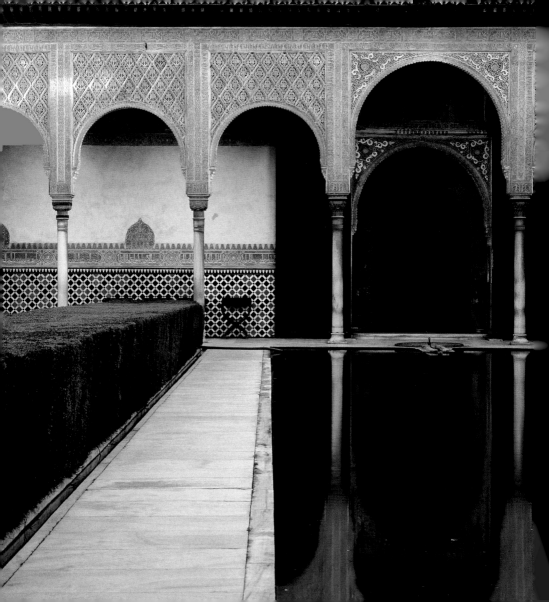

# Tamed, subdued water

O f all the hidden beauty of the palaces it is probably that of the water which holds the most secrets. Leaving behind the Cuarto Dorado, the visitor enters the hidden Alhambra, where handicrafts, polychrome plaster and tiles are superimposed, illustrating the richness of Nasrid decorative arts. Poems inscribed on walls and fountains and mysterious symbols indicate the conceptual richness. But it is probably the water which is the greatest treasure. The fountains in the palaces of the Alhambra are not merely decorative. It is as if the Nasrids, proud of their discoveries, had wanted to illustrate their capacity to tame water, to play with it as they wished. Bringing water to the Alhambra could not have been easy: there was a lot of it on the snow-capped peaks of the nearby mountains, but the raised site of the grounds meant that channels had to be constructed. With the construction of the ditches which irrigated the neighbouring fertile land, the Nasrids learnt how to tame water. The fountains of the palaces are no more than proof of this knowledge. The pattern of small channels which link fountains and pools is simple in appearance, but in reality it requires a complicated technique: There are channels which slope against the current in order to retain the water, places where the channels narrow in order to increase the thrust of the water, cavities and bends which alter the flow of the water, and all this without a murmur or a crash, so that the surface of the water in the pools remains constantly still and the images reflected in them are never distorted. But this is not only an aesthetic game or an ostentation of technique. Here, the water also serves to reduce the effects of the extreme continental climate of Granada. The two big courtyards, The Court of the Myrtles and the Court of the Lions, are purposefully designed to take advantage of the shade in summer. The water cools the atmosphere creating currents of air and the fine plaster work, in the form of lattices, gives shelter from the sun and lets the air pass through. In winter, the sun glitters in the water and the marble, warming the air. The courtyards were always the centre of life at home for the Nasrids and they received the utmost care and most recent innovations.

*←·· Court of the Myrtles*

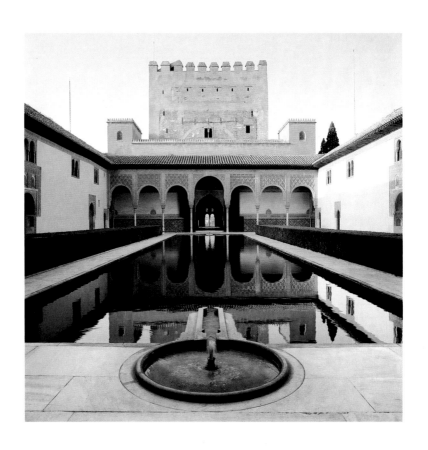

*Court of the Myrtles*

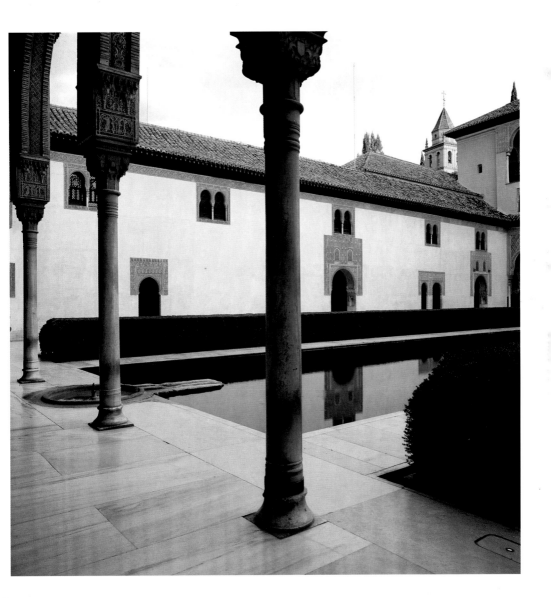

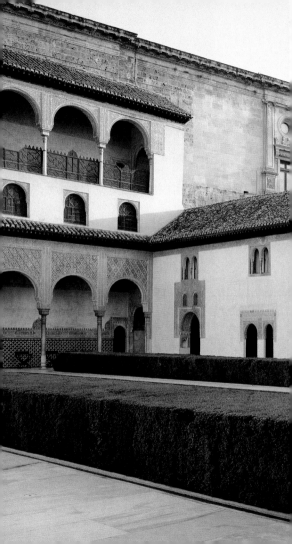

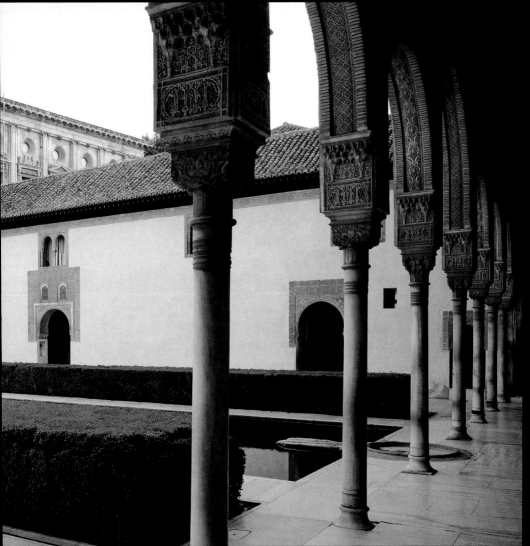

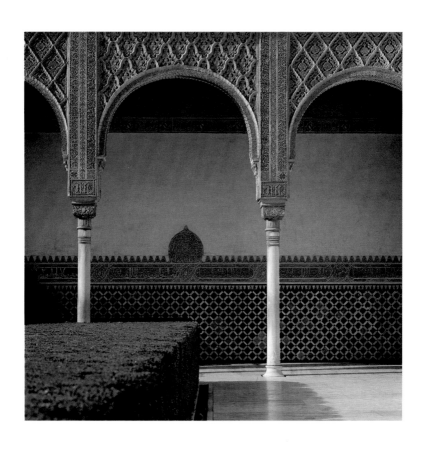

*Comares Palace* ⇡
*Comares Palace. The Northern side* ⤍
⬱ *Court of the Myrtles*

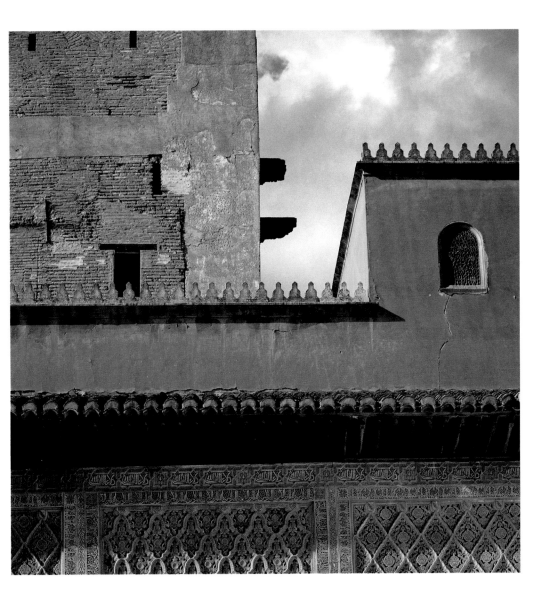

*Comares Palace* ⋯→

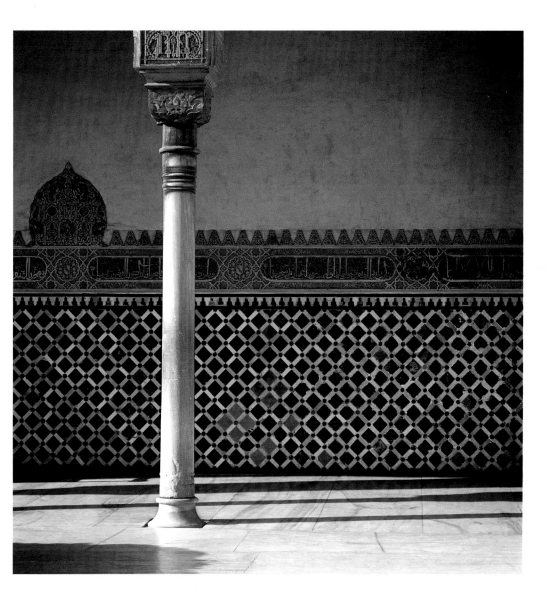

*Comares Room* ⋯→

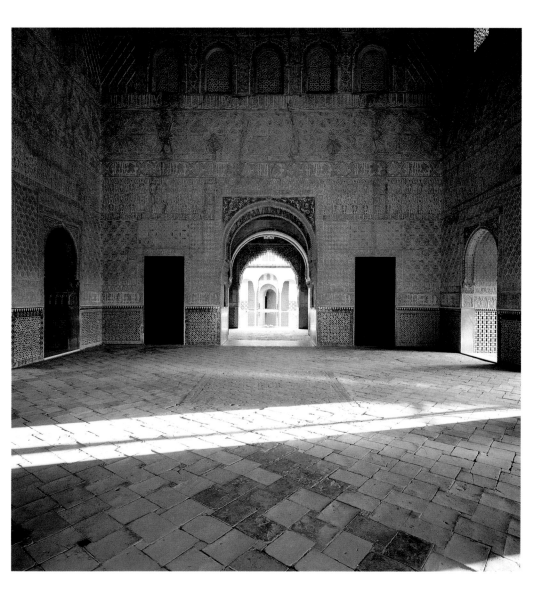

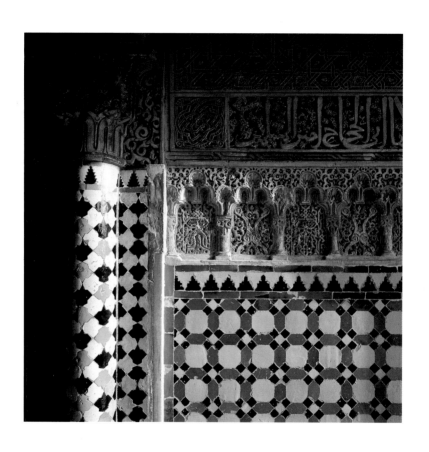

*Comares Room*

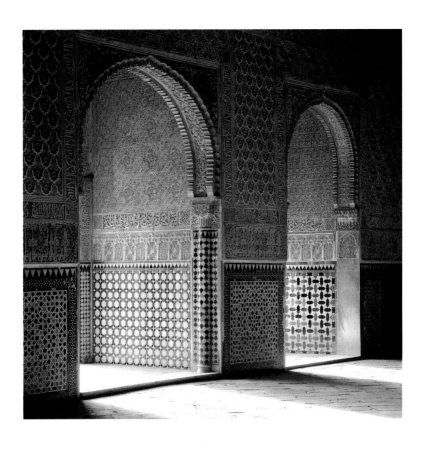

*Comares Room*

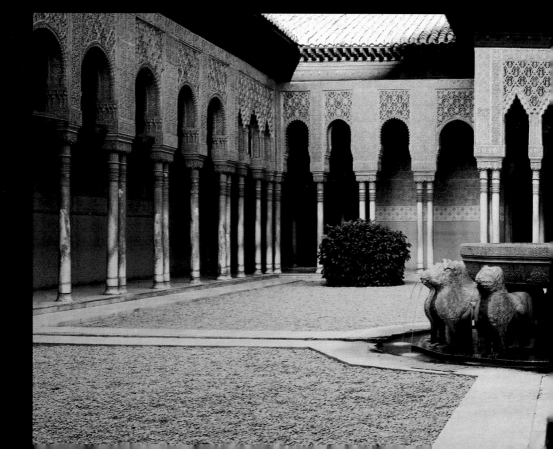

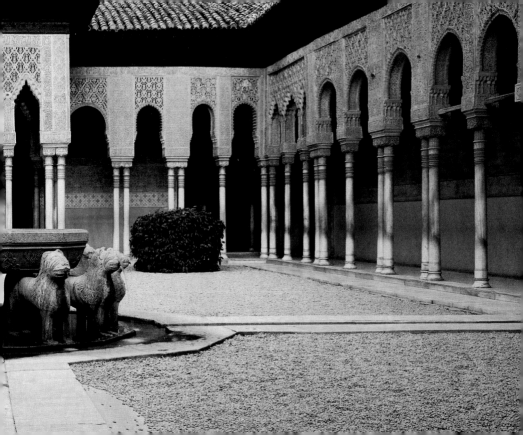

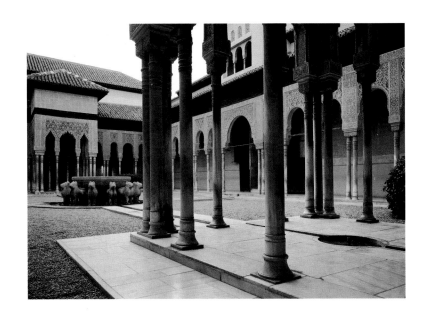

*Court of the Lions*

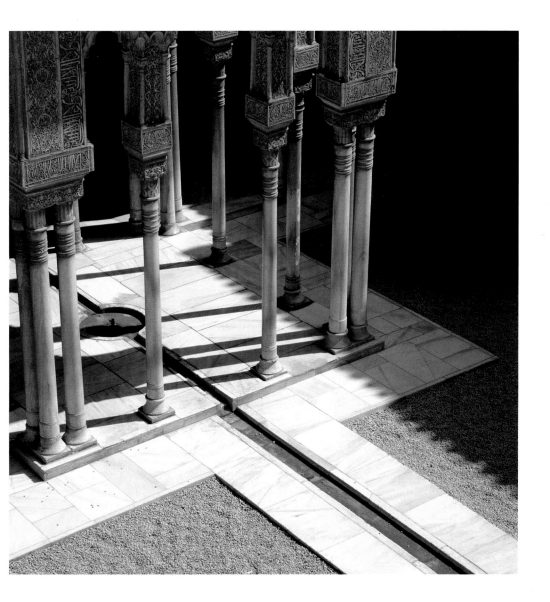

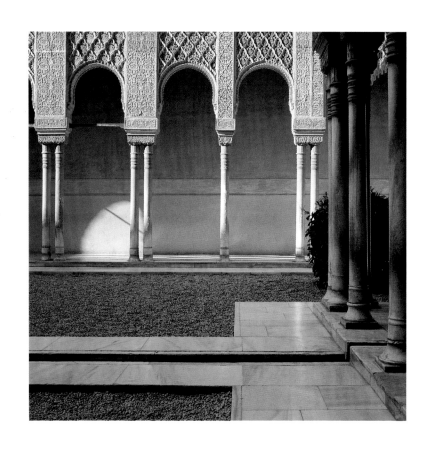

*Court of the Lions*

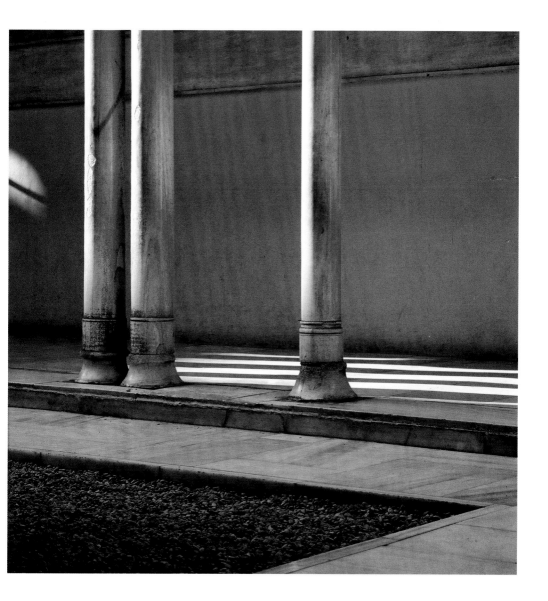

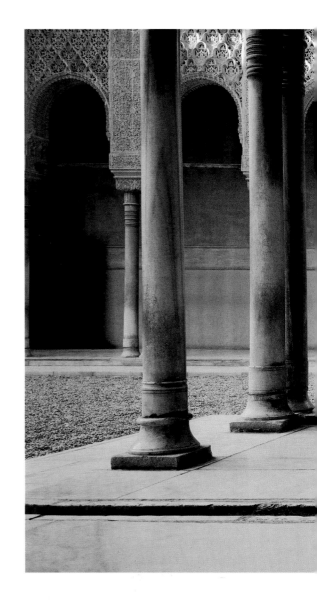

*Court of the Lions*

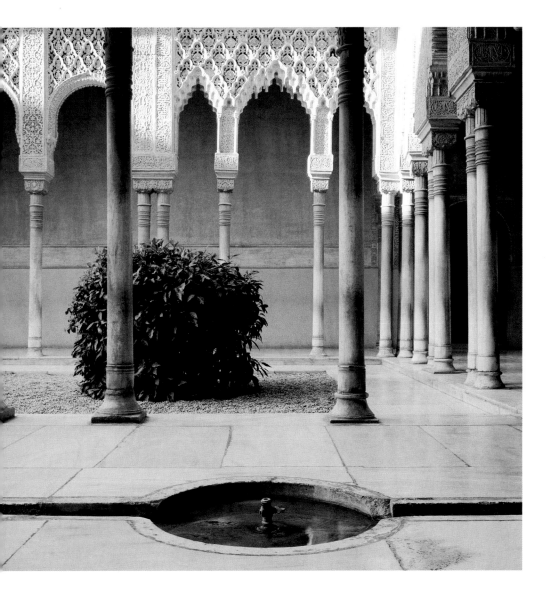

*Court of the Lions* ⋯→

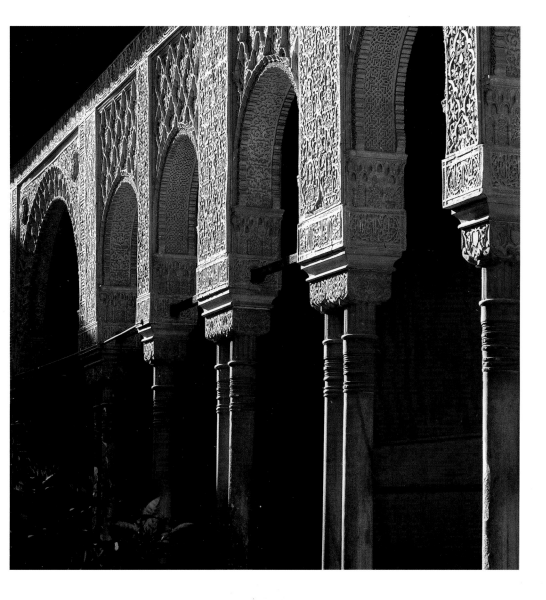

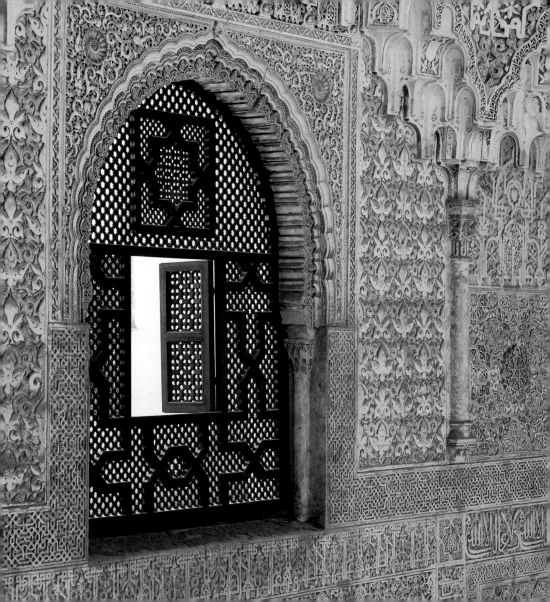

# The realm of illusion

t is difficult to separate the Alhambra from its rediscovery by the Romantics in the 19th century. It must be agreed that the Alhambra does not only belong to the Nasrids who built it, but to all those who have passed through it: from the Christian conquerors to the tourists and sellers of souvenirs in the present, including the monks, nobles and gypsies who have lived there during the last five centuries. And, of course, the Alhambra also belongs to the Romantics who forged its legends. It couldn't be otherwise: stories of love and death, passionate glances hidden by lattice screens, acts of treason. It is impossible to distinguish here between reality and illusion. Of the entire palace precinct, it is perhaps the area surrounding the Court of the Lions that which has given rise to the most obscure tales. Like the one that gives its name to the Hall of the Two Sisters. According to this tale, two imprisoned sisters died of desire on observing a couple secretly making love in a nearby garden. Nearby, the room of the Abencerrajes has a tale backed by the Viscount of Chateaubriand, one of the creators of the romantic illusion of the Alhambra. This story is more plausible, as it tells of the frequent bloody battles between rivals in the Nasrid kingdom and also uses the sources from various historical accounts. Next to the fountain, on the decline of Nasrid power, various members of the family of the Abencerrajes had their throats cut. There are also even vaguer versions which talk of fights which broke out due to the jealousy caused by a member of the Abencerrajes who wanted to court one of the favourites of the sultan. To give credence to the legend, there are those who say that they can see traces of blood in what is really rust on part of the marble basin in the centre of the room. Above, there is a small room which is fascinating without the need of a legend. It is called the courtyard of the Harem. But if reality is really to be confounded with hallucination, there is no need for more stories. It is sufficient to observe the domes of mocarabes which cover either of the two rooms until one becomes dizzy.

*←·· Hall of Two Sisters*

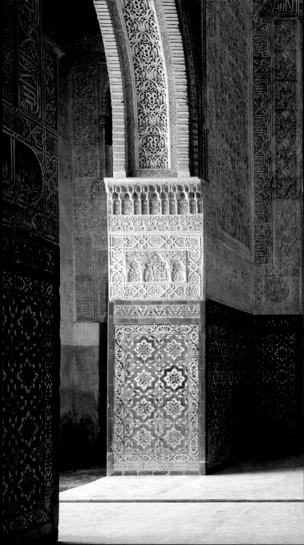

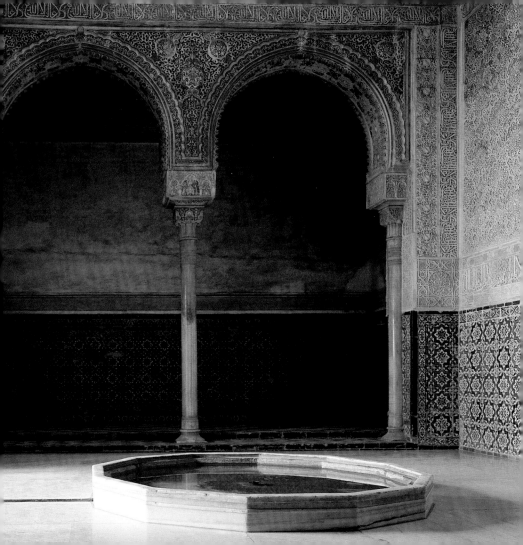

*Hall of Two Sisters* ⋯→
←⋯ *Hall of the Abencerrajes*

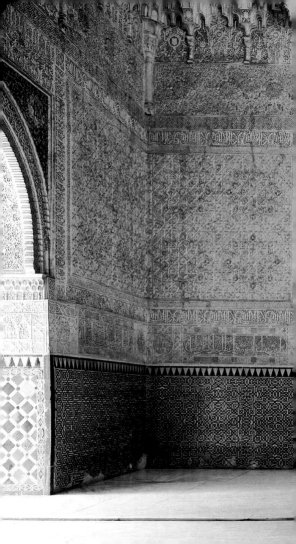

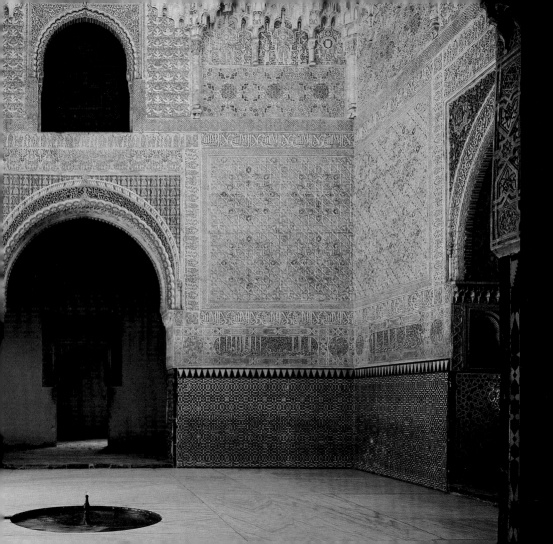

*The water channel in the Hall of Two Sisters* ⋯⟶
⟵⋯ *Hall of Two Sisters*

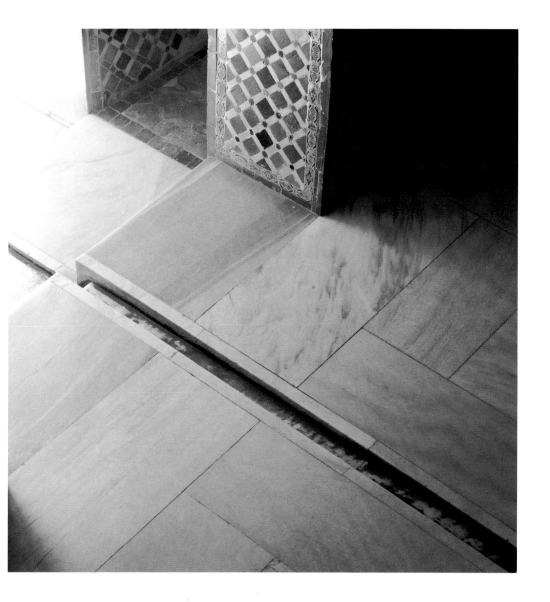

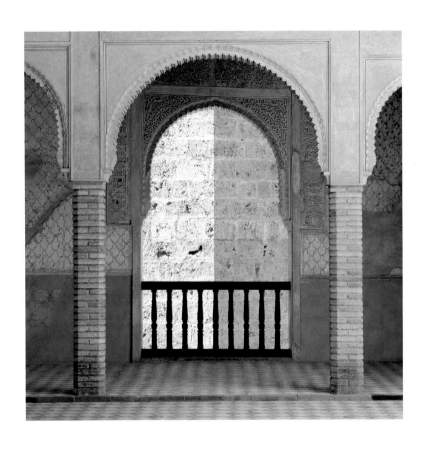

*Court of the Harem*

# Death in the orchard

The romantic atmosphere of the Alhambra comes not only from the 19th century travellers who "discovered" it and made it world famous. Part of this atmosphere comes from the many mysteries which still surround it. Some are mysteries of banal appearance, although they are important to appreciate the daily life in the palaces and the citadel. For example, it is unknown which areas of the precinct were used as kitchens. Neither do we know of the existence of any chimney, except those built after the defeat of the Nasrids. The *rauda* is another mystery. This Arabic word referred to two things at the same time which for us are totally different: the cemetery and the garden. Two concepts which were associated for Muslims, whose idea of paradise is similar to that of an orchard. The rauda is situated next to the tower on the boundary of the south wing of the palaces. This is the tower of the Rauda, whose function is unknown, but which could probably be related to the funeral ceremony celebrated before burials. The tower, as if it were a metaphor of the transition from life to death, is situated at a junction: that which sepa-

rates the palaces from the surrounding areas. At the same time, it signals the border between Nasrid architecture and Imperial architecture, represented by the Charles V Palace. Also separate from the palaces is the tower of the Queen's Dressing Room. The very name is suggestive of the breathtaking views overlooking the horizon which extends beyond the other two hills in Granada: The Albaicín and Sacromonte. Next to this is a Renaissance row of balconies which breaks with the rough defensive appearance of the Alhambra seen from the north. The row of balconies was built in the time of the Emperor Charles V and belonged to the private chambers of the Empress. It is as if here the new owners of the Alhambra had wanted to compete with their predecessors in aesthetic sensitivity. A lot of care was put into these chambers, which were even equipped with a hidden mechanism for maintaining the rooms perfumed. The Emperor had now nothing to fear from the Muslims, who were defeated and driven out. In less than half a century the situation had changed completely: some frescos illustrate the military expedition which Charles V sent to conquer Tunisia.

*←·· The Rauda*

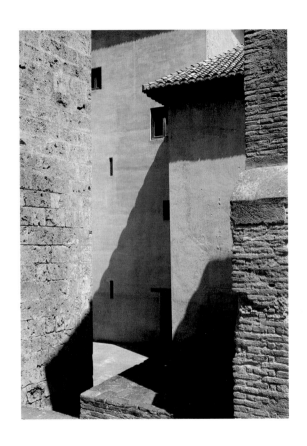

*Lower Royal Street* ⇡
*Entrance to the Rauda* ⇢

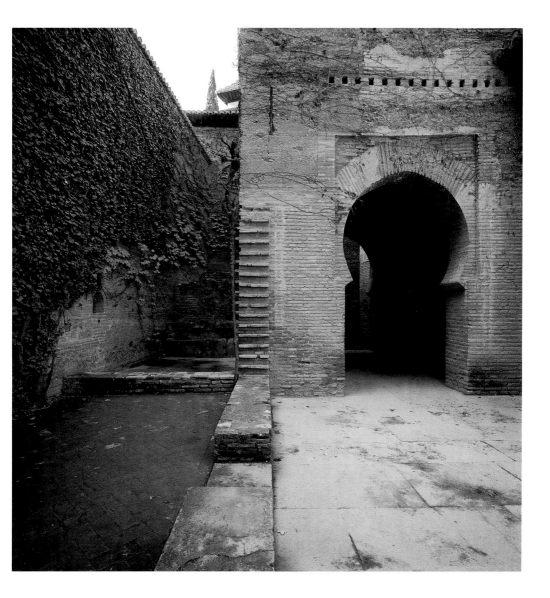

*Entrance to the Rauda* ⇢

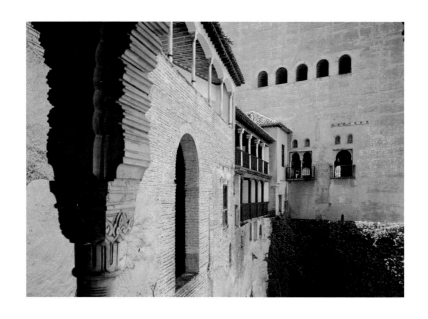

*Galleries of the Queen's Dressing Room and the Court of the Iron Grille* ⤒
*The Abu-l-Hayyay or Queen's Dressing Room Tower* ⤍

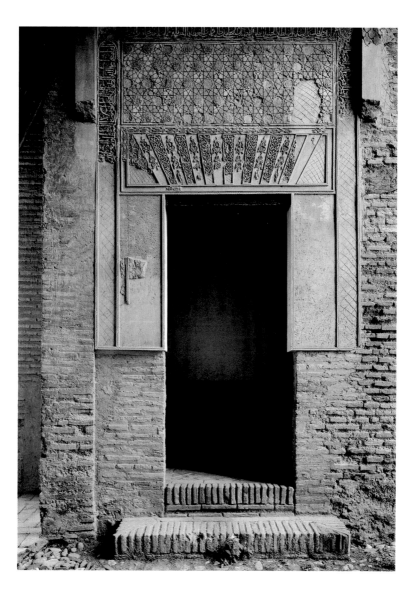

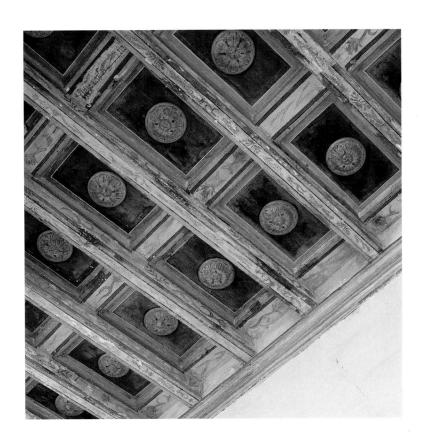

*Queen's Dressing Room*

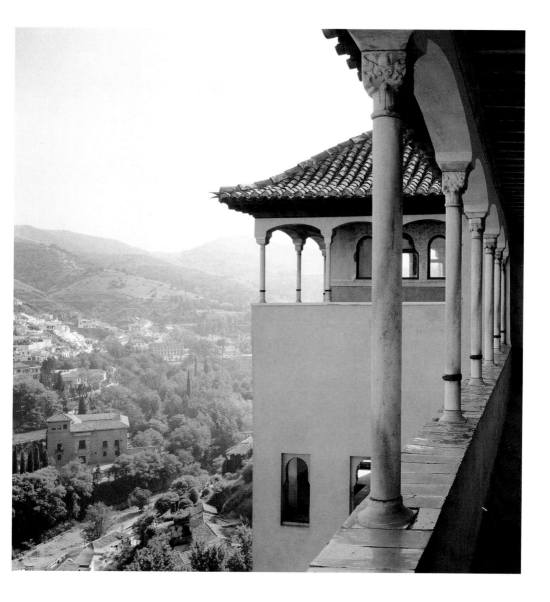

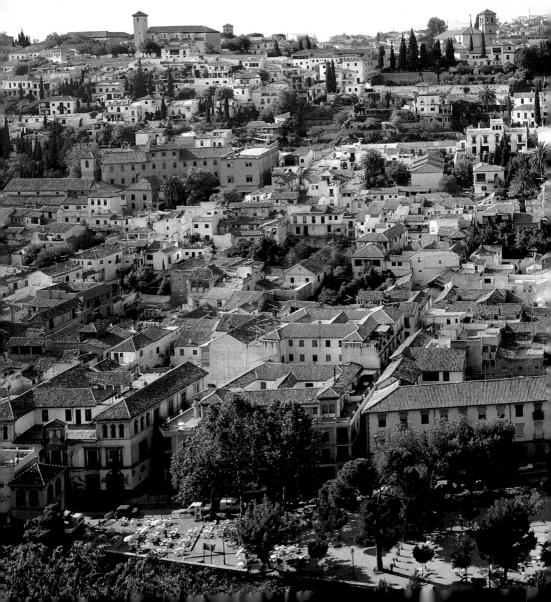

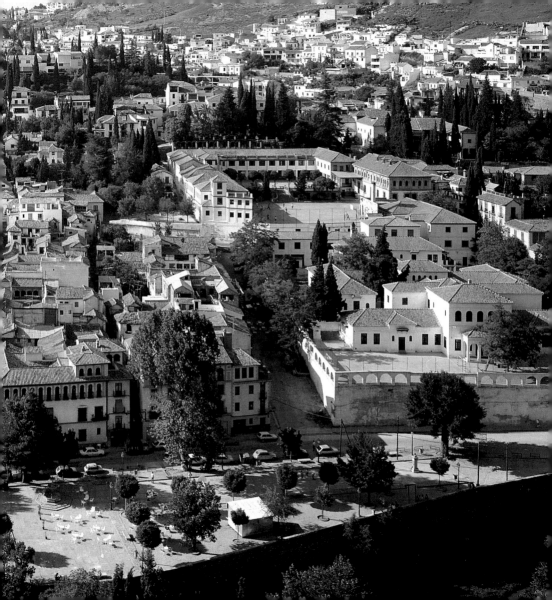

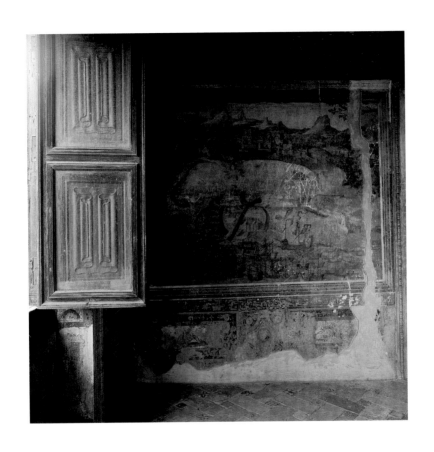

*Queen's Dressing Room* ⬆
*Comares Tower* ⋯➤
⬅⋯ *The Albaicín*

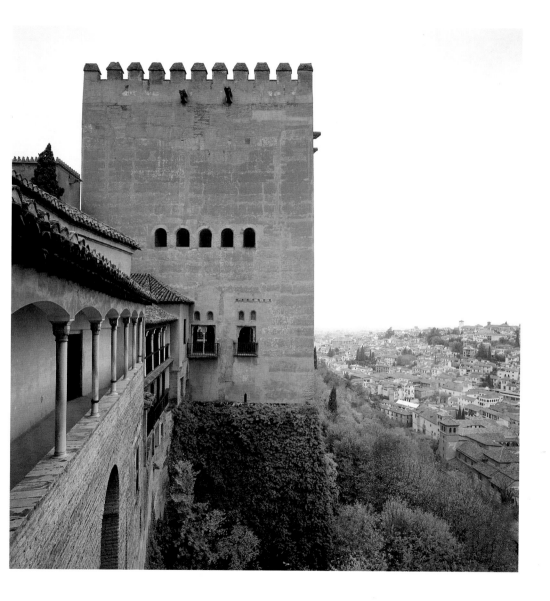

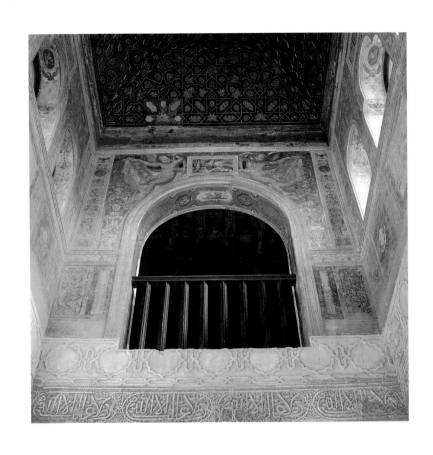

*Queen's Dressing Room*

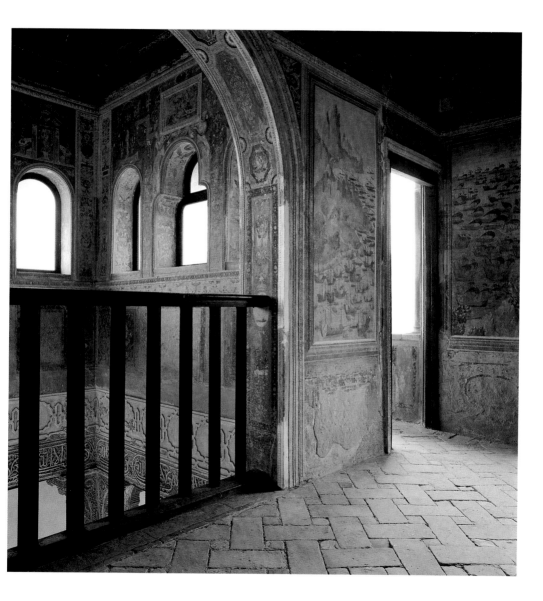

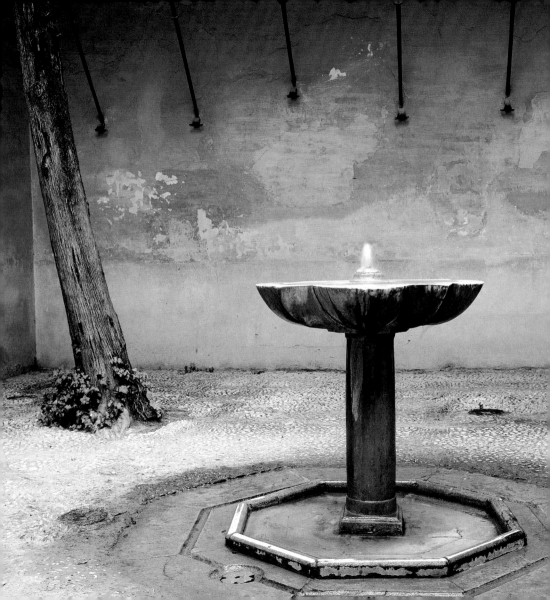

# Hideaways

n the centre of the palaces, the baths of the Alhambra are situated in a passageway between the palaces and the Emperor's chambers. Their beauty may be deceiving. To our eyes they may seem sumptuous, but there is no difference in the technique or decoration between these baths and those found in other cities of Muslim Spain. The only thing which makes them different is what was added later, as is the case with the dado of tiles installed in the 16th century. In the Arab world, communal baths were – and still are – of central importance to social life. They are a meeting place. The baths of the Alhambra are beyond the indiscreet eyes of curious onlookers. However, from behind the windows of the upper floor, those inside could look out. Next to the baths, the temporary chambers of Charles V were built while his palace was under construction, rooms which were also used by other distinguished guests, such as the writer and diplomat Washington Irving. Just to the north of the baths is one of the most peaceful places in the precinct: el patio de la Reja, attached to the Emperor's chambers. Four old cypresses occupy the four corners of this small courtyard above which there runs a row of balconies protected by the wrought iron grille that gives its name to this place. On the other side of these chambers the patio de Lindaraja is enclosed. Laurels, cypresses, orange trees and box hedges are imprisoned by a kind of cloister. In the Nasrid period, before the Emperor's chambers were built, the patio de Lindaraja was not an enclosed area and from here the hills of the Albaicín and Sacromonte could be seen. It was a place with lots of light which accentuated the view from the balcony of Lindaraja , to the north of the Palace of the Lions. Today, the patio de la Reja and the patio de Lindaraja are, more than ever, isolated from the complex of the Alhambra. Both are favourite places for regular visitors trying to escape from the crowds of astonished tourists visiting the palaces and to seek shelter from the summer heat.

*⟵ Court of the Iron Grille*

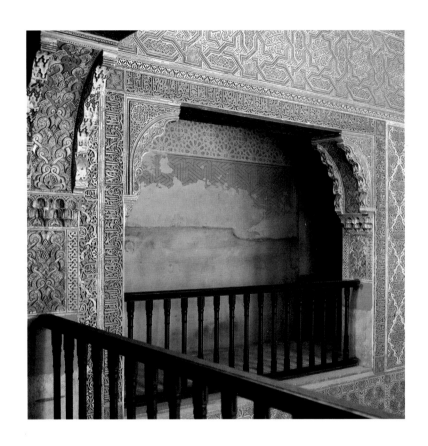

*Comares Bath. Hall of the Beds*

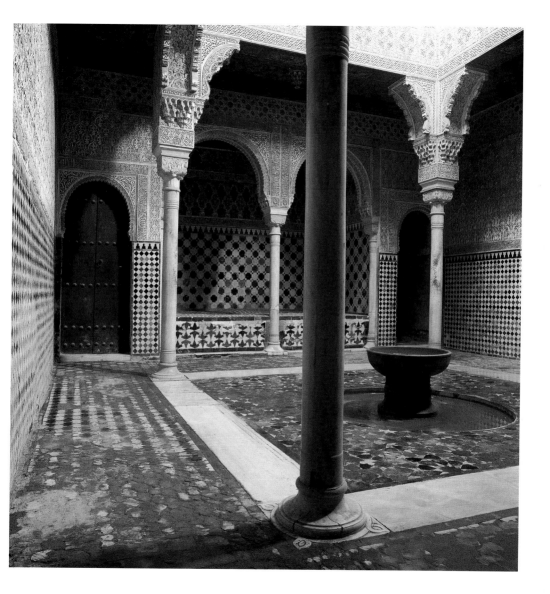

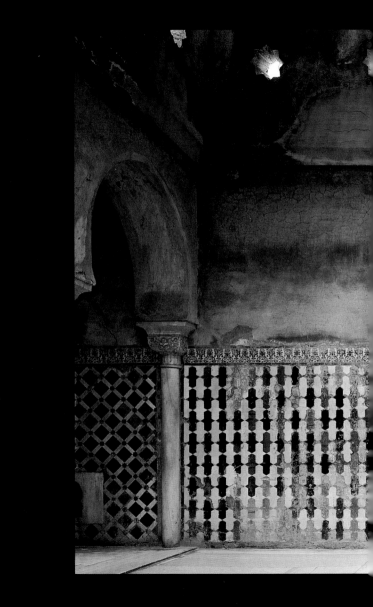

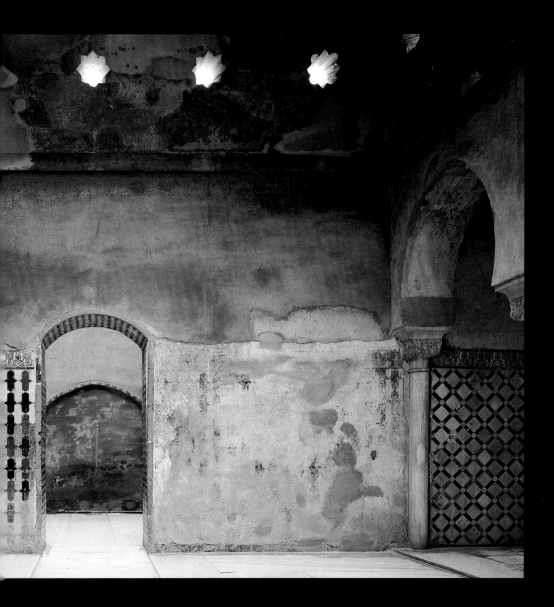

*Comares Palace. Cold Room* ⋯⇢
⇠⋯ *Comares Palace. Steam Room of the Bath*

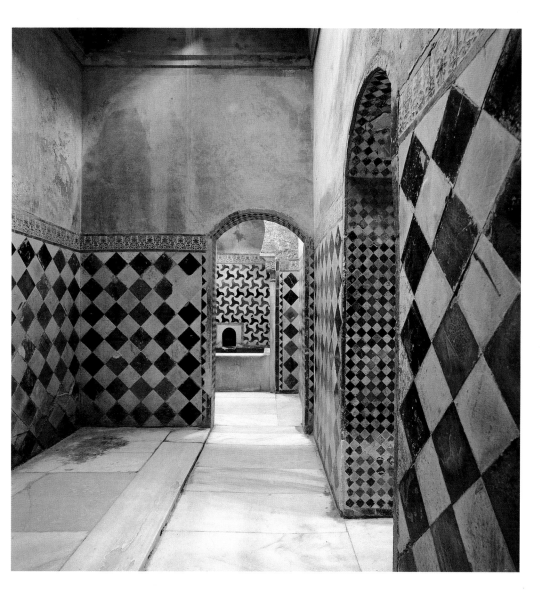

*Court of the Iron Grille*

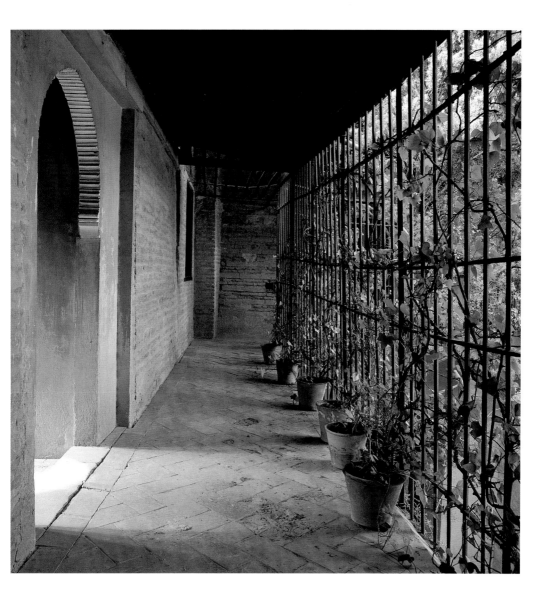

*Court of the Iron Grille* ⋯➔
*Court of Lindaraja* ⋯➔⋯➔

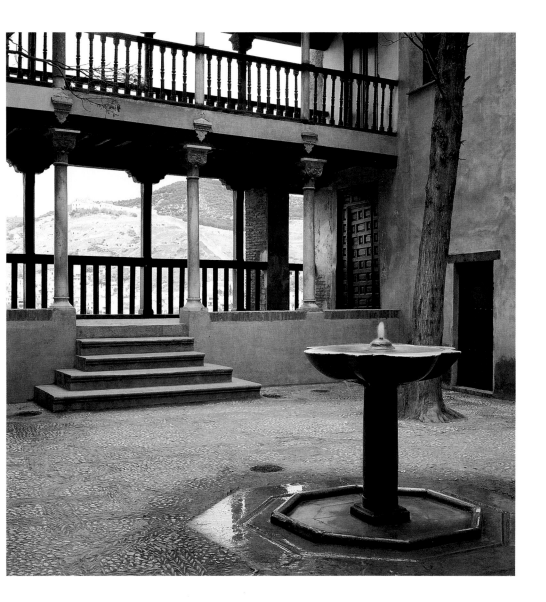

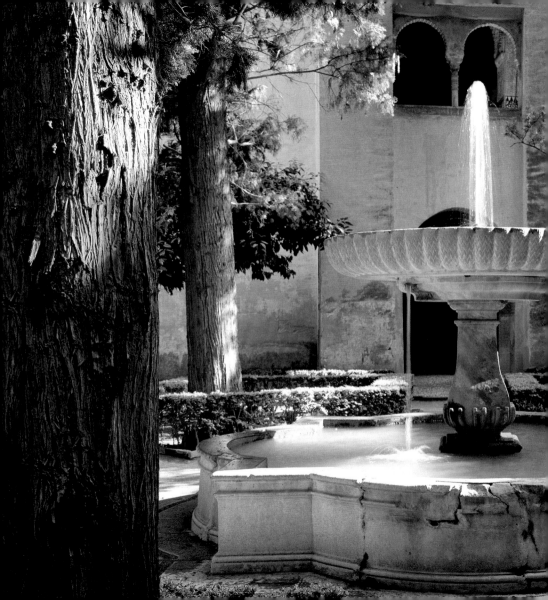

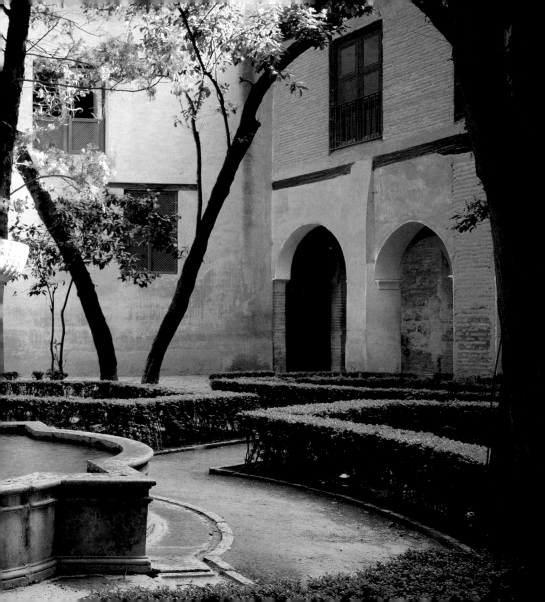

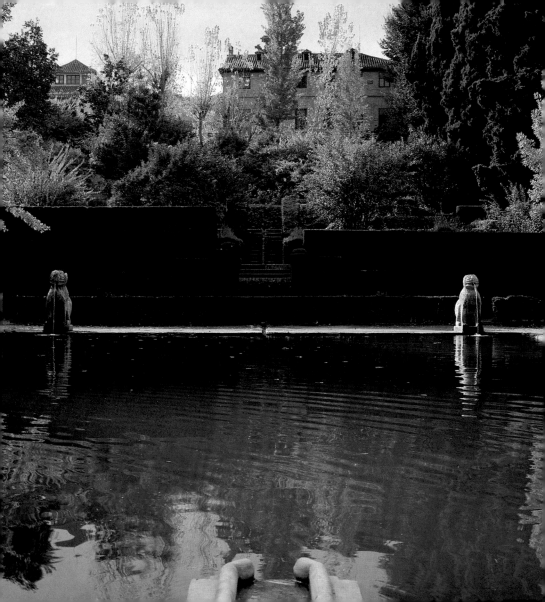

# Gardens over a forgotten city

El Partal, to the east of the patio de Lindaraja, is the true picture of a Nasrid palace. This portico is shown in all its splendour. There are no walls to hide it nor nooks and crannies through which one has to pass in order to discover it. El Partal, lacking the enchantment of mystery, seems today to adorn the gardens which surround it, as if it were a romantic device rather than a vestige of the past. Behind it is the balcony and the Torre de las Damas, one of the oldest buildings in the Alhambra. A residential building attached to one of the walls saved it from deterioration caused by exposure to the elements; thus, we can see that not only the interior of this palace had been richly decorated, but also that the exterior was covered with stucco. Today the water and the trees seem to take away some of the importance of the Partal. Only vegetation encloses the space around the great pool which lies in front of the portico and encompasses diverse relics of the Alhambra. Fountains, pools and vegetation join together the scattered remains in this area giving them coherence. Where the gardens of the Partal are today, there were streets and houses in the Nasrid period. Of these there remain only four, one of which contains some interesting frescos which, in spite of being quite modest, are the key to an enigma. This house is called the house of paintings. On one of the walls, inside this humble looking house, frescos were discovered at the beginning of the 20th century. These frescos are rare evidence of Muslim pictorial arts and disprove some beliefs held up to that time. The blurred figures of the warriors on horseback prove that there was no prohibition against the illustration of living beings and that the abundance of inscriptions and dramatic geometrical patterns are more a product of a vision of the world rather than the consequence of a rule of the Koran which experts have considered inexistent.

←·· *Gardens of the Partal*

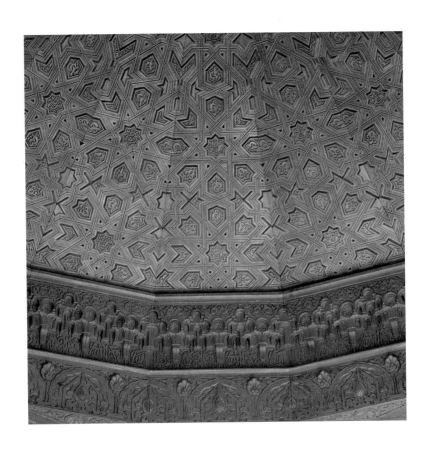

*Palace of the Partal* ⇧
*Oratory of the Partal* ⇢

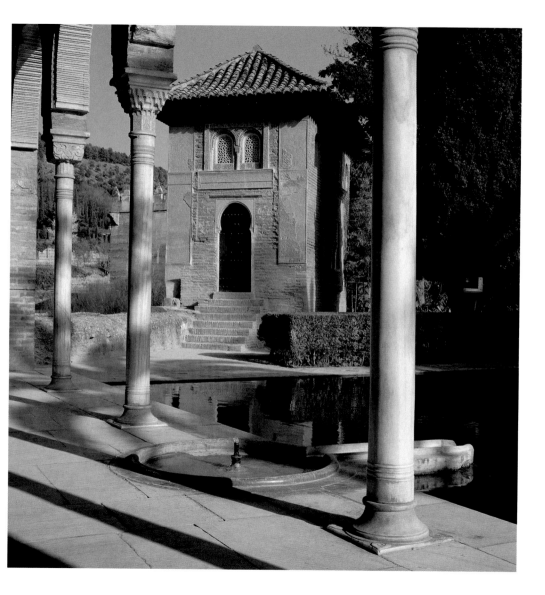

*Maristán Lion* ⇢

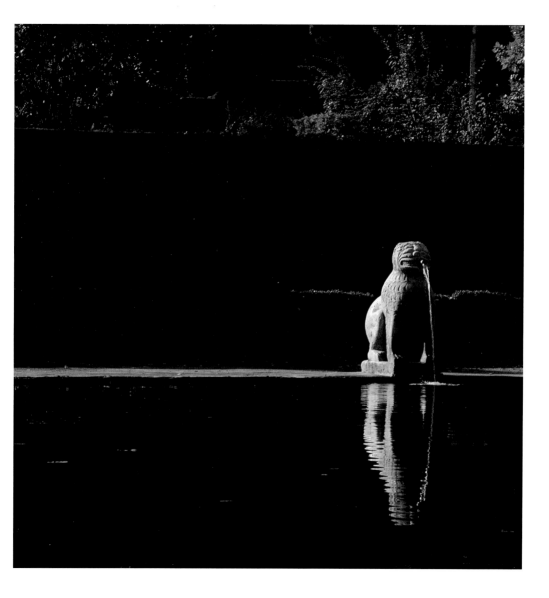

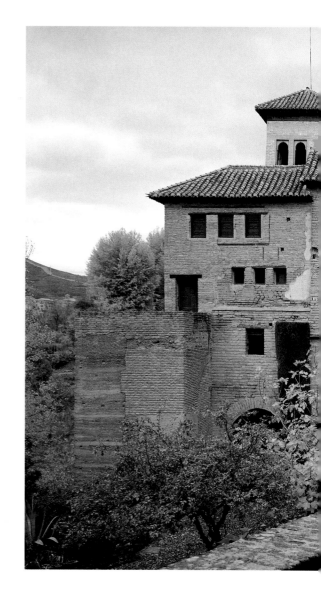

*Houses in the Partal (16th century)*

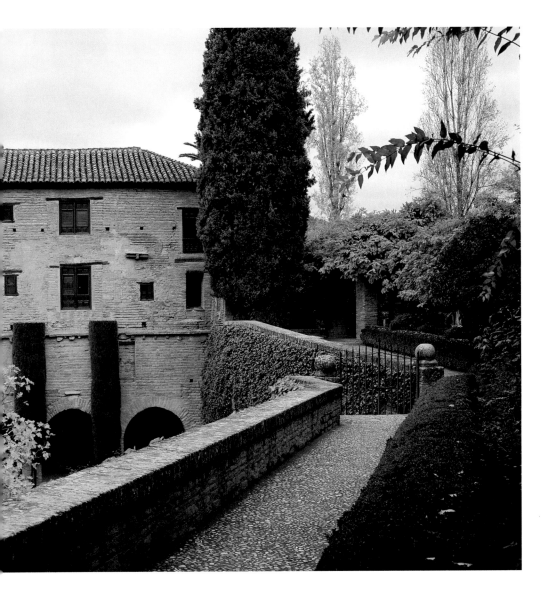

*House of paintings*

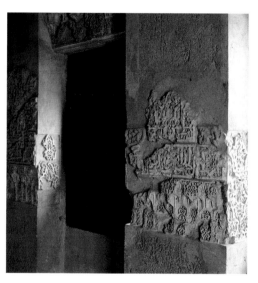

*House of paintings*

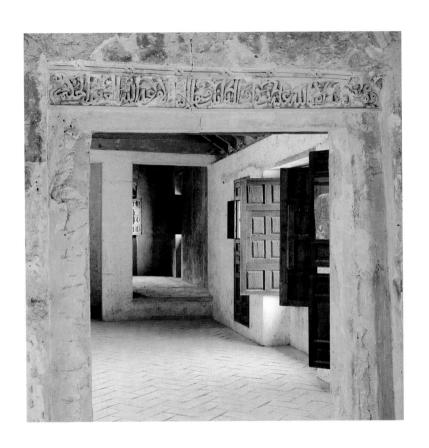

*Houses in the Partal. House of paintings*

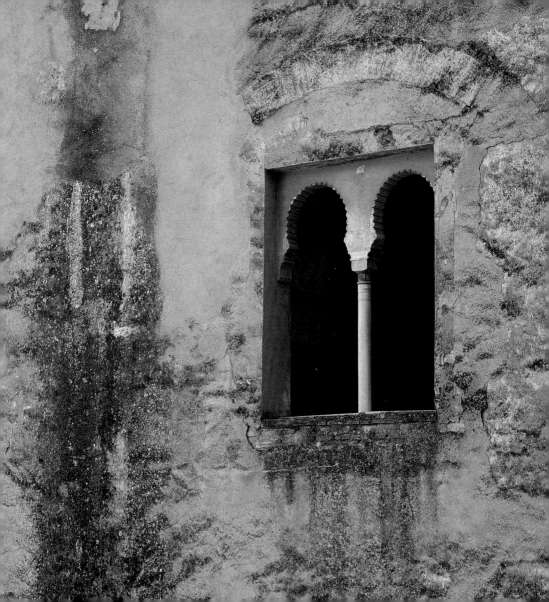

# One flank for love and another for war

The towers of the Alhambra with their evocative names constitute a long, resounding list of legends and mysteries. Torre del Adarguero, del Agua (of the Water), de Alquiza, de la Barba (of the Beard), de la Bruja (of the Witch), de las Cabezas (of the Heads), del cabo de la Carrera (of the end of the Route), del Cadí (of the Judge), del Candil (of the Oil Lamp), de la Cárcel (of the Prison), de la Cautiva (of the Captive), de las Damas (of the Ladies), de la Estufa (of the Stove), de las Gallinas (of the Hens), de Giafar, de las Infantas (of the Princesses), de la Justicia (of Justice), de la Ladrona (of the Thief), del Paso de la Zorra (of the passing of the Vixen), de la Pólvora (of the Gunpowder), del Preso (of the Prisoner), de los Puñales (of the Daggers), de Siete Suelos (of Seven Floors). La Torre de las Infantas – which still maintains this name since the 17th century – inspired Washington Irving to write the legend of the secret loves of Zaida, Zoraida and Zorahaida, the three daughters of a jealous sultan. In the Alhambra, romantic legends of love seem to be reserved for the most finely decorated places, which are those that also are open to the charms of the hills running towards the north, on the other side of the river Darro. Sentimental fantasy encompasses the gallery of the Queen's Dressing Room, the Hall of the Two Sisters and the Towers of the Princesses and of the Captive. The latter was also called the Tower of the Thief, the Tower of the Ladies or the Tower of the Sultana, but the final name became the Tower of the Captive, which refers to a Castilian prisoner, Isabel de Solís, who became the favourite of one of the last Nasrid sultans, Muley Hasan, with whom she had two children. But whilst the area around the palaces on the northern flank was the scene of romances, the southern flank, more open to possible sieges, is related to acts of war and bloody treason. This is the case of the Tower of the Seven Floors, in front of which great processions and jousting tournaments were held. It is said that at this gate the Alhambra was handed over to the Catholic Monarchs. Fables of war also continued to accompany this place much later on, up to the defeat of the Muslims. Opposite, in 1812, a Spanish veteran soldier cut the wick which Napoleon's troops had lit to destroy the Alhambra. There are engravings from the 16th century which illustrate that the gate of this tower was bricked up. This gave rise to the belief that it was through this gate that Boabdil left the precinct after requesting that the entrance should be closed after his departure.

*⟵ Tower of the Princesses*

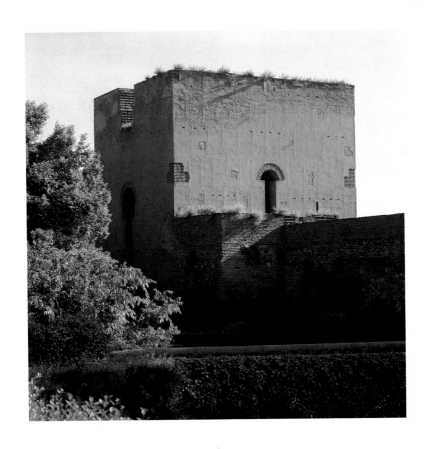

*The Water Tower*

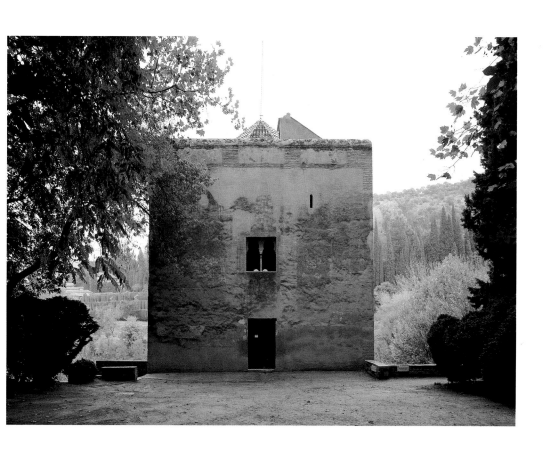

*Tower of the Princesses*

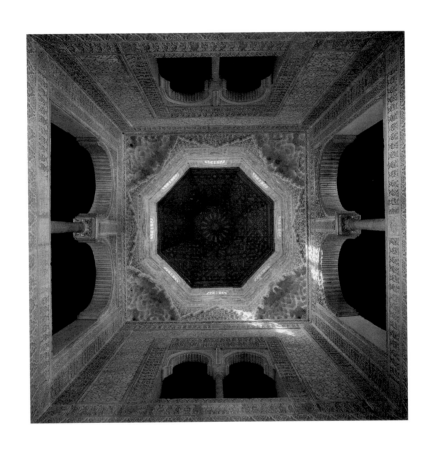

*Tower of the Princesses*

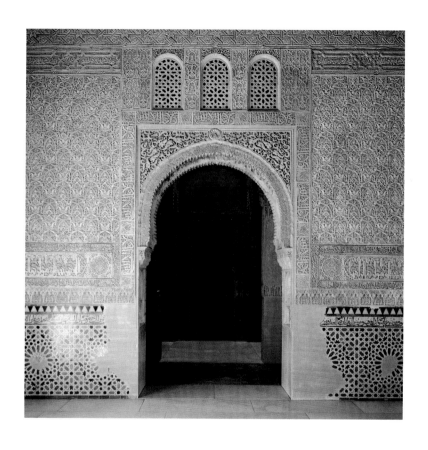

*Tower of the Captive*

149

*Tower of the Captive*

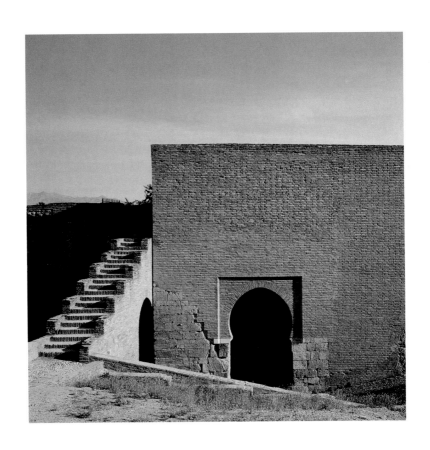

*Tower of the Seven Floors*

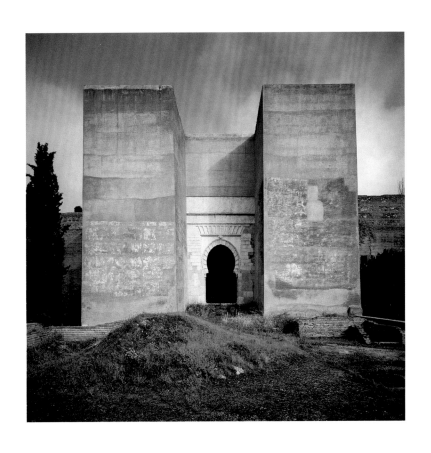

*Tower of the Seven Floors*

*Comares Tower* ⇢

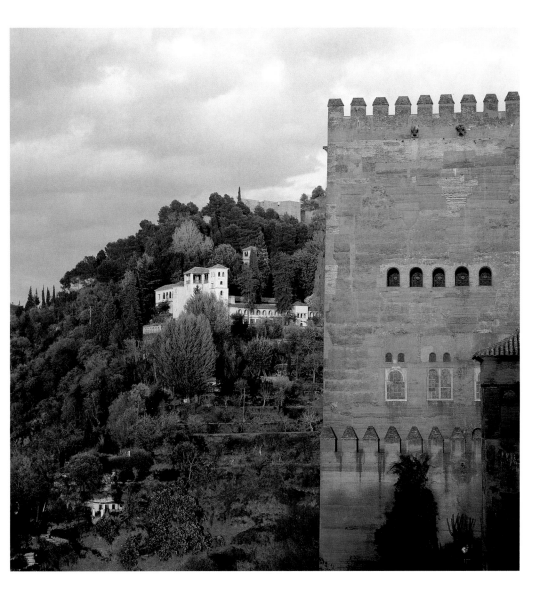

# The Sultan's heavenly pantry

To the east of the Alhambra, making use of the flow of water from the royal irrigation ditch, on the hill situated between the rivers Darro and Genil, farmsteads and country houses began to appear. The old tales of the Generalife illustrate that this was a very fertile area. It could not have been otherwise: here the volume of water is four times that of the volume which reaches the Alhambra and there was much less need of it. The abundance of water allowed the Nasrids to try to recreate in this land the paradise with which the Koran promised to reward them after death: a fertile garden, with flowing rivers, full of fruit trees, palm trees and flowers, with shady nooks in which they would lie on beds lined with brocades, accompanied by youths and shy virgins "with large dark eyes like well conserved pearls". The Generalife serves to illustrate the ideal of a Nasrid garden. Outside the walls, there are no limits to the Generalife. However, its gardens follow the same pattern as those in the Alhambra. They are not gardens which extend into infinity, like European gardens, but secluded gardens, imprisoned between walls and pavilions. In spite of the fact that here there are no curious onlookers from which to hide, the gardens are transformed into intimate places where only the water brought by the irrigation ditches is given right of way. Perhaps these gardens are designed according to the dictates of the Koran: the irrigation channels are underground rivers, and the pavilions are shaded spots where one can enjoy peace, wine which doesn't go to one's head, and the pampering of the nymphs and youths. Lacking in bold devices, it does not seem that this paradise was intended to impress visitors, but rather to move them. It is the vivid sum of vegetation which fills it with smells and colours to which is added the luxury of the abundance of water. But the fountains here are not a decorative element but rather, in any case, proof of prosperity and well-being. It is a pleasant place, but, although it attempts to recreate paradise, it is an accessible paradise, made to the scale of man's senses.

*←·· Palace of the Generalife*

*Gardens of the Generalife*

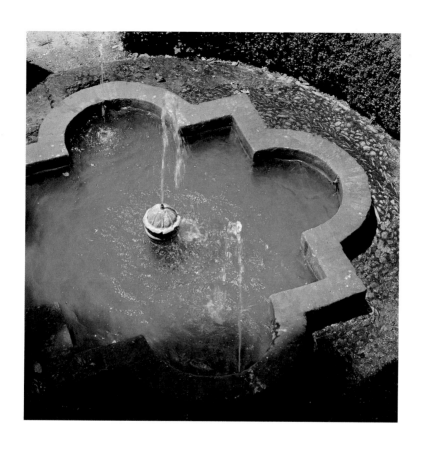

*Gardens of the Generalife*

*Palace of the Generalife* ···>

<··· *Gardens of the Generalife*

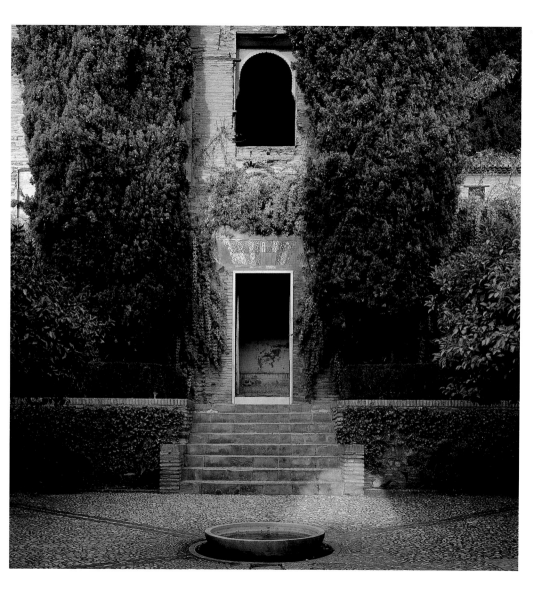

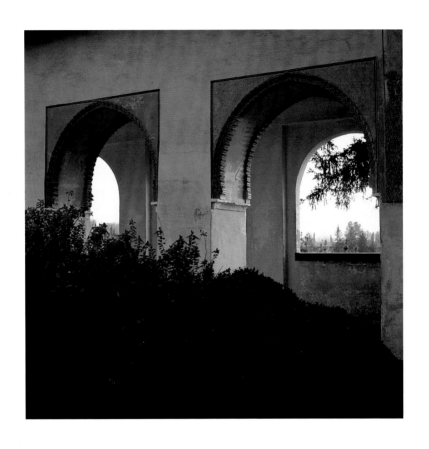

*The gallery in the Court of the Water Channel* ⇡
*Court of the Water Channel* ⇢

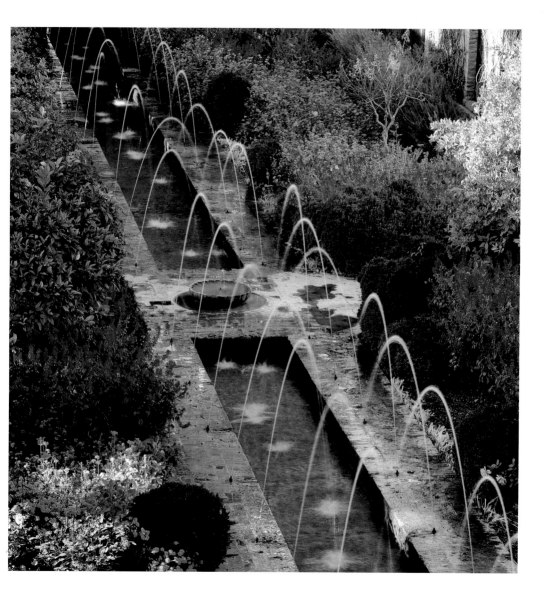

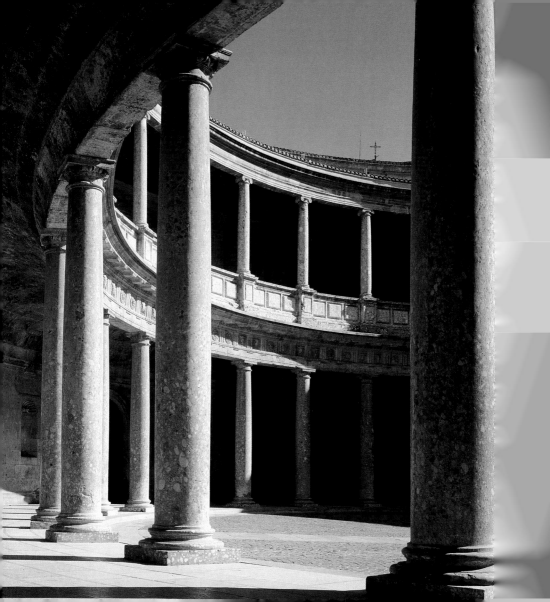

# The ghostly trace of the empire

f the Nasrid buildings of the Alhambra and The Generalife are evidence of a lifestyle, the Charles V Palace, almost fitted onto the Nasrid palaces, is a vestige of a spirit; the essence of the empire. The Nasrids did not seem to aspire to leaving any trace of their presence in these places: the poor quality of the materials which they used to build their palaces seems to indicate this. The Muslim Alhambra has a vanishing splendour and the visitor is captivated by the reflection of a lifestyle rather than by its beauty. The Charles V Palace, on the other hand, seems to be made to belittle the beholder. It is built conscientiously, with lasting materials, such as stone. The Nasrid palaces did not have a façade: all their beauty was hidden. On the other hand, the Charles V Palace is, more than anything else, a façade. Indeed, it was nothing more until well into the 20th century. It maintains the name of the emperor who had it built, but who could never live in it. The construction of the palace presented a host of problems. The walls and the impressive line of columns in the courtyard took nearly a century to build, but nearly another four hundred years would pass before, in 1931, the roof was finished. In the final years of Muslim presence in Spain, the Christian Monarchs developed a mixed style of architecture, inspired by the Muslims and developed in part by their technicians and artesans: it was called Mudéjar. But, in the 16th century, Imperial Spain wanted to leave its stamp on everything that was built, choosing exquisite architecture and with the idea of it being everlasting. It was solid and serious, having nothing to do with the secret sensuality of the Nasrid gardens and palaces. This was the spirit of the empire, a spirit which was probably imposed even upon those who reigned. It is said that Charles V himself did not agree totally with the idea of destroying the Muslim legacy. It is known that on seeing the cathedral that the religious authorities of Córdoba had built in the centre of the city of the great Mezquita, he was visibly angry: "What cannot be found anywhere has been destroyed in order to build what can be seen anywhere". As if it were a punishment on imperial self-importance, the Charles V Palace was a ghostly ruin until quite recently. On the other hand, traces of the Nasrids still remain intact five centuries after their defeat. As alive as the gardens irrigated by the water which they themselves brought to this humble red fortress.

*Charles V Palace*

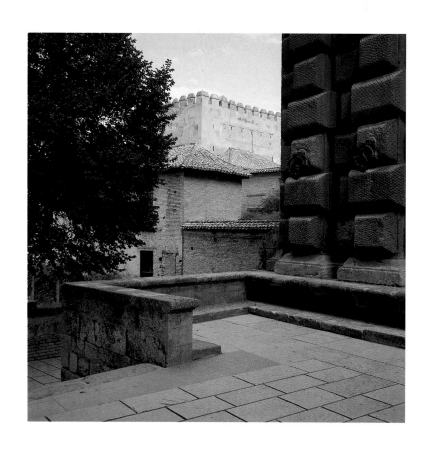

*Charles V Palace and the Nasrid palaces* ⬆
*Charles V Palace* ⤳

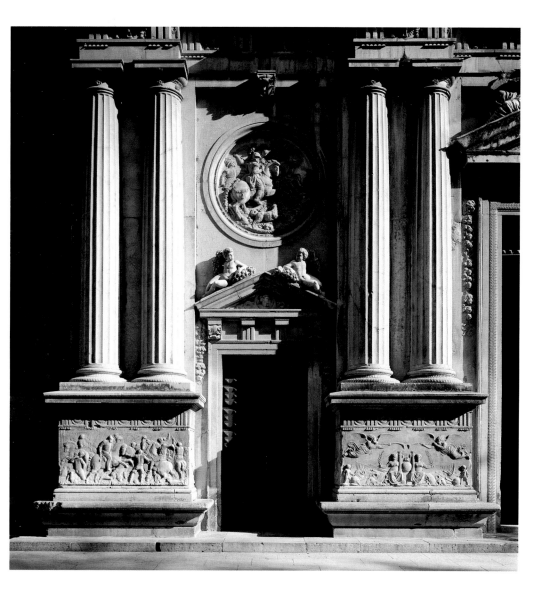

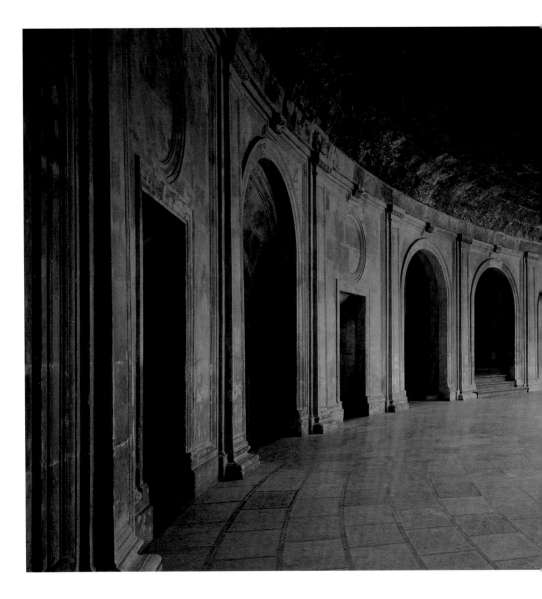

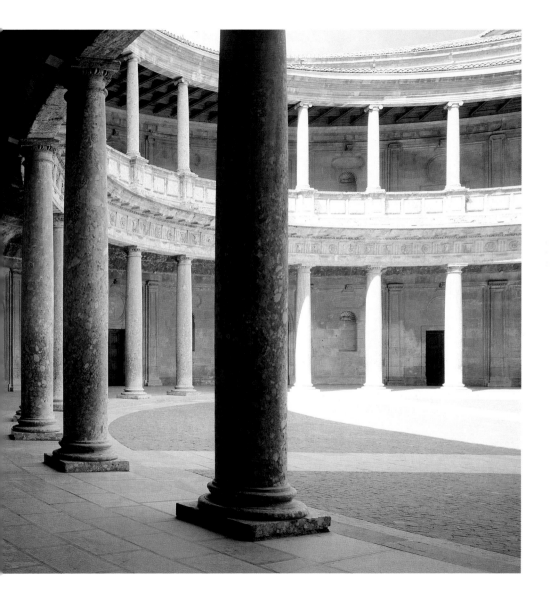

*Charles V Palace* ⋯→
←⋯ *The Courtyard of the Charles V Palace*

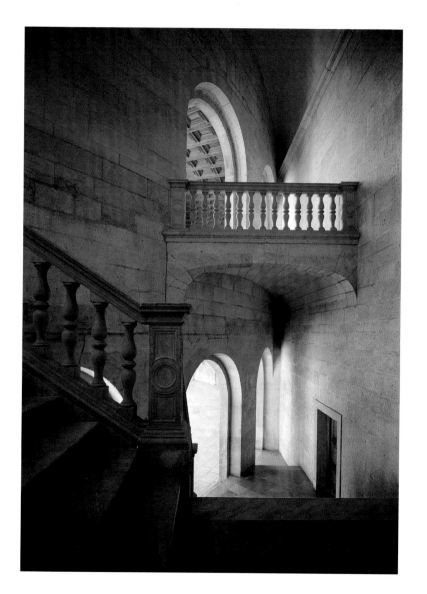

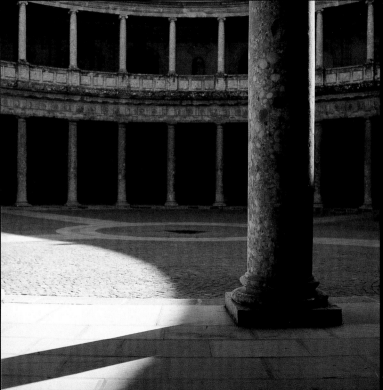

**Captions** for Photographs

### 7. The Alhambra Wood

Area known as Las Alamedas (The Poplar Groves). Detail of an irrigation channel which takes water along the paths of the Wood to the lower city.

### 8-9. The Alhambra from the Albaicín

From the right emerges the terrace of the Vermilion Towers; in the centre is the Alcazaba (Fortress) overlooked by the Watch Tower and the Homage Tower; immediately behind are the Nasrid Palaces around the great Comares Tower, and behind this, the Charles V Palace.

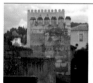

### 12. Torre de las Gallinas
(Tower of the Hens)

Behind it, is the Comares Tower. To the left, above the parapet of the wall, the Generalife appears.

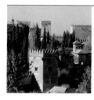

### 14. The Tower of the Spikes

This tower defends the entrance to the Alhambra through the Puerta del Arrabal (the Gate of the Outskirts), situated at the foot of it. On the right we can see the portico and the terrace of the Palace of the Partal, in front of the great Comares Tower.

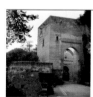

### 15. The Justice Gate

The most monumental of the outer gates of the Alhambra, built in 1348 by the sultan Yusuf I. In front of it is the Christian bastion for the artillery and coronation of the Renaissance pillar of Charles V.

### 16. The Wine Gate. Western façade

Above the symbolic key, below the twin window, the inscription mentions the Sultan Muhammad V who must have redecorated the portal some time after 1368, although the Gate was erected a lot earlier, between 1303 and 1309.

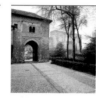

### 17. The Wine Gate
Interior or Eastern Façade

Muhammad V had this Gate decorated after 1368, from where the Calle Real (the Royal Street) of the Alhambra leads through the whole city. Behind are the towers of the Fortress.

### 18. The Homage Tower
(13th century – 14th century)

Detail of the Homage Tower, whose profile is outlined against the sky at twilight.

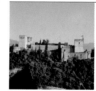

### 20. The Fortress of the Alhambra
(11th to 16th century)

The large towers at the tips were added to the central wall by the Nasrids in the 11th century; in the 16th century the Tower of the Nobles on the right and the Bucket Tower on the left were added.

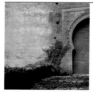

### 21. The Arms Gate

Detail of the outside façade of the Arms Gate, the usual entrance to the Alhambra in the time of the Nasrids.

## 22. Detail of the outer Eastern wall of the Fortress

In this picture the different stones used in the repairs of the wall can be seen.

## 23. Curtain wall of the Fortress at the base of the Homage Tower

After the Christian conquest of the Alhambra, the defence of the Fortress was reinforced in this sector with a new stretch of wall and the Bucket Tower; in the background is the entrance stairway to the terrace of the Bucket Tower.

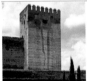

## 24-25. The Homage Tower
(13th century – 14th century)

Perhaps the most important tower of the Alhambra, because from its privileged position, it overlooks, guards and controls the fortress. At the foot of this is the Bucket Tower and the wall, added in the 16th century.

## 26. Detail of the Northern Wall of the Fortress (11th century)

The Nasrids reinforced the Zirid walls with a curtain wall or walkway around the perimeter of the ancient fortress.

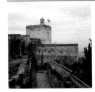

## 27. Main Entrance to the Alhambra from Granada

The Arms Gate, in the background, was the main entrance to the Nasrid Alhambra along a sunken walkway, carefully controlled by the three stretches of wall around the Fortress. In the background is the Watch Tower.

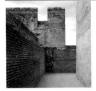

## 28. Barbican or curtain wall of the Fortress

In order to go inside the Fortress it is necessary to go along a walkway protected by the walls or curtain wall; on the right is the base of the Watch Tower, on the western side.

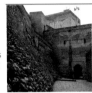

## 29. Interior façade of the Arms Gate

This was the main entrance to the Medieval Alhambra, through the gate and along the walkway of the curtain wall. Above is the Watch Tower.

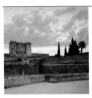

## 30. Partial view of the Fortress

From the terrace of the Arms Gate, the upper part of the Zirid wall can be seen. Above this are the Watch Tower and the Broken Tower; also visible are the tops of the trees in the Garden of the Ramparts.

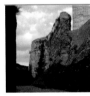

## 31. Walkway of the curtain wall

The Bucket Tower, in the background, obstructed, from the 16th century, the final stage of the Medieval walkway which entered the Alhambra.

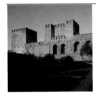

## 32. Interior of the Fortress
The Arms Gate (14th century)

Inside the Fortress is the area of the living quarters of the military, known as the Military Precinct which occupies the whole of the Arms Square. In the background are the Homage Tower and the Broken Tower.

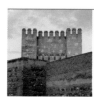

### 33. The Broken Tower
(14th century)

This tower presents in the upper part of the Western side a solution of two advanced floors, unique in the Alhambra.

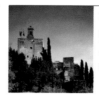

### 39. Western side of the Fortress

From the ravelin the splendour of the Watch Tower is emphasised; on the right is the Torre de la Pólvora (Tower of the Gunpowder).

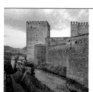

### 34. North side of the Fortress, from the Arms Tower

In the centre is the Homage Tower which watches over and controls the entrance to the Alhambra along the sunken walkway of the lower curtain wall.

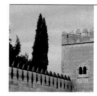

### 40. Torre de los Picos
(Tower of the Spikes) 13th – 15th century

Detail of this strategic tower and of an outer sector of the wall, which control one of the outside walkways of the Alhambra.

### 35. Fortress, northern side

Detail of the entrance to the terrace of the Arms Gate.

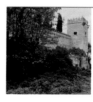

### 42. Wall and Tower of the Spikes

Outside view of the walled precinct of the Alhambra, from the Cuesta del Rey Chico. At the foot of the Tower the bastion for the artillery can be observed, completely remodelled from the 16th century.

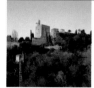

### 36-37. The Fortress of the Alhambra on the southern flank

In the centre is the Watch Tower, below which runs the ravelin for the artillery. In the foreground is the wall which connects the Alhambra to the Vermilion Towers.

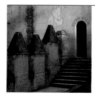

### 43. The wall of the Alhambra

This picture shows the path from the battlements to the inside of the tower called the Tower of the Judge, in the section of the wall between the Tower of the Judge and the Tower of the Spikes.

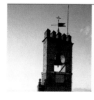

### 38. Belfry of the Watch Tower (1882)

Initially, the bell of the Watch Tower was placed in the north-western corner of the Tower, and was transferred to the centre in 1840; the current bell dates from 1773.

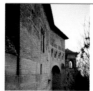

### 44-45. Detail of the outside sector of the Northern wall of the Alhambra

The palace complex of the Alhambra, in some areas, "flies" above the main wall to appear above the Albaicín, el Valle del Darro and the lower city: Cuarto Dorado (Gilded Room), the Mexuar chapel and Torre de Machuca.

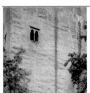

### 46. Torre de la Cautiva
(Tower of the Captive. 14th century)

The Sultan Yusuf I (1333-1354) had this tower built. Inside are some of the most beautiful decorative elements in the Alhambra; it is called Torre Qalahorra due to the inscriptions inside.

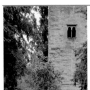

### 47. Tower of the Captive

From the Cuesta del Rey Chico several towers can be seen to stick out from the main wall. The importance of these towers in terms of construction and decoration has led to them being called palace towers.

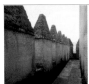

### 48. Walkway along the battlements

Detail of the walkway along the battlements of the wall of the Alhambra in the sector of the Comares Tower (on the right).

### 49. Torre de las Gallinas
(Tower of the Hens)

Inside view of this small but important tower in the northern sector of the Alhambra. Its layout corrects the difference in level of two stretches of the general wall.

### 50. Patio of the Cuarto Dorado
(the Gilded Room). Detail of the tiles

One of the most noteworthy decorative elements of the Alhambra are the panels made by joining together different pieces of cut glass in different combinations.

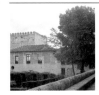

### 52-53. Forecourt of the Alhambra palaces

Visits to the Alhambra palaces are organised in a forecourt known as the Placetas. In the picture, on the left, is the Patio de Machuca, above which appears the Comares Tower; The Charles V Palace is on the right.

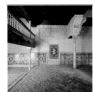

### 54. Inside the Mexuar

In order to increase the size of the Chapel inside the Mexuar it was necessary to incorporate, in the 16th century, the area of an adjoining courtyard which was converted into choir stalls.

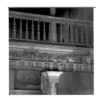

### 55. Balustrade of the Mexuar

In striking contrast to the Muslim decoration of this area is the wooden balustrade of the choir stalls in the Mexuar.

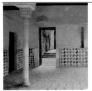

### 56-57. The Mexuar

The Mexuar is one of the areas of the Alhambra which have suffered the greatest number of reforms: at the beginning of the 14th century it was the Throne Room; later, it became an antechamber and room for meetings; finally, in the 16th century it became part of the Chapel.

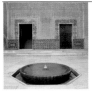

### 58. Court of the Gilded Room

On the southern side of the courtyard stands the majestic façade of the Comares Palace, built in 1370 to commemorate the conquest of Algeciras by the Nasrid forces.

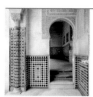

### 59. Mexuar and Gilded Room

Detail of the passage between the Mexuar and the porch of the Gilded Room.

### 60. Gilded Room

Detail of the ceiling covering the Gilded Room, whose name refers to the fact that it was repainted in the Mudejar tradition.

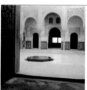

### 61. Court of the Gilded Room

The courtyard used as a hallway to the Comares Palace receives the name of the room which opens onto it through this beautiful portico.

### 63. Court of the Gilded Room

Detail of the Eastern façade of the Court. In contrast to the Northern and Southern Façades which are finely decorated, the Eastern and Western façades are bare.

### 64. Detail of the decoration of the façade of the Comares Palace (1370)

The whole façade highlights the greatness of the Sultan who would give audience to his subjects before it.

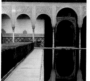

### 65. Court of the Gilded RoomFaçade of Comares
(14th century)

This majestic façade is also emphasised by the steps situated in front of it. On each side, at right angles, the wall decoration continues.

### 66. Comares Palace. Court of the Myrtles. Southern Portico
(14th century)

One feature of Nasrid architecture is the presence of porticos which open out onto the courtyard from the sides.

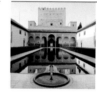

### 68. Comares Palace. Pool, Northern Portico and Comares Tower

This place in the palatine city of the Alhambra can be considered as the canon of excellence of Nasrid architecture.

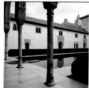

### 69. Comares Palace. Court of the Myrtles, from the Northern gallery

One of the most spectacular contrasts in the architecture of the Alhambra is attained when we look for diagonal perspectives in different contexts.

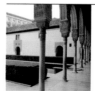

### 70-71. Comares Palace Court of the Myrtles

The courtyard is the central area of domestic architecture which, in the case of the palaces, attains maximum beauty and splendour.

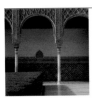

## 72. Comares Palace
Detail of one of the colonnaded galleries

The light from below helps us to appreciate the decorative details of Nasrid architecture.

## 73. Comares Palace
Detail of the northern side

The geometry of the architecture, which is developed in the Alhambra through the superimposition of cubic structures, is another noteworthy achievement.

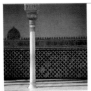

## 75. Comares Palace
Detail of the base of one of the porticos

The lower surfaces of the walls, lined with panels of tiles, stress the Mediterranean reference in Andalusí or Hispano-Muslim Art.

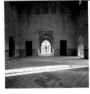

## 77. Comares Palace. Inside the Comares or Throne Room

This room of the Alhambra contains, more than any other place, the finest synthesis of Nasrid Art.

## 78. Comares Room
Detail of the decoration of one of the alcoves

The walls of this room illustrate a varied collection of geometric, epigraphic and floral elements of decoration.

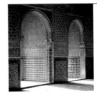

## 79. Two alcoves of the Comares Room

The impressive Comares Tower, the largest in the Alhambra, contains, inside the width of its walls, nine alcoves which give shape to the Sultan's Throne Room.

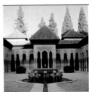

## 80-81. Palace of the Lions. Courtyard and Fountain of the Palace
(14th century)

This area represents the culmination of the process of evolution of Nasrid palatine architecture, which has led some writers to define it as the Nasrid Baroque.

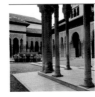

## 82. View of the courtyard of the Palace of the Lions

The forest of columns which surrounds the entire perimeter of the Court of the Lions in the form of a portico is one of its most famous features.

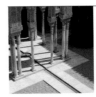

## 83. Palace of the Lions
Detail of one of the pavillions of the Courtyard

Amongst the elements which stress the geometry of the Court of the Lions are the two large pavilions which jut out from the centre of its shorter sides.

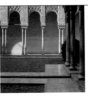

## 84. The Court of the Lions

Detail of the galleries which completely surround the court.

### 85. Detail of the columns of the gallery of the Court of the Lions

The strict but proportionate verticality of the columns contrasts with the horizontal plain marked by the passages of the galleries.

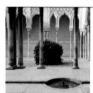

### 86-87. The Court of the Lions from the interior of one of the pavilions

Another noteworthy feature of the galleries of the Court of the Lions is the play of light and dark, which creates different tones of light throughout the day.

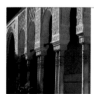

### 89. Detail of the decoration of the galleries of the Court of the Lions

If one looks closely enough, the galleries present a variety of types, arrows and intensity of light in their arches, which accentuates their marked geometry.

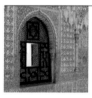

### 90. Palace of the Lions
Window and Lattice screen inside the Sala de dos Hermanas (Hall of Two Sisters)

The interior architecture of the Palace of the Lions is equally capable of offering surprising and practical solutions.

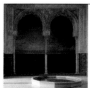

### 92-93. Palace of the Lions
Hall of the Abencerrajes

Even in the interior of the Palace, the light seems to be incorporated into the architecture as another element of the decoration of the Alhambra.

### 95. Fountain in the Hall of Two Sisters

The geometric concept arises from the square inscribed in a circle as static elements to which is added colour – tiles and plaster-work – to set them in motion.

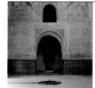

### 96-97. Palace of the Lions
Hall of Two Sisters

The use of geometric patterns is a constant feature of Nasrid architecture; in this room the cubic projection of its square floor can be seen.

### 99. Detail of the water channel in the Hall of Two Sisters

Also in the interior architecture the channelled water plays an important role.

### 100. Porticos of the Court of the Harem

In spite of the numerous transformations undergone in the Alhambra, the combination of architecture, light and colour is still one of its greatest formal, plastic values.

### 101. Court of the Harem
Detail of one of the porticos

Remains of wall paintings conserved in the Alhambra are scarce but they are significant in form and concept.

### 102. Gardens of El Partal
Detail of the fabric of the walls next to the Entrance to the Rauda

The different materials used in the construction – and reconstruction – of the Alhambra illustrate a diversity and richness of beautiful textures.

### 104. Lower Royal Street of the Alhambra

This is the place where the Comares Palace (in the background), The Palace of the Lions (on the right) and the Charles V Palace (on the left) converge.

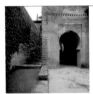

### 105. Gardens of El Partal Entrance to the Rauda

Sometimes, the simplest and humblest materials, like bricks, give rise to proportionate compositions of great beauty, as seen in the picture.

### 107. Gardens of El Partal. Detail of the Entrance to the Rauda

The materials used in the construction and the architectural form are combined in plays of surprising figurative quality.

### 108. Galleries of the Queen's Dressing Room and the Court of the Iron Grille
In the Background, the Comares Tower

The Renaissance also appreciated the value of the landscape of the Alhambra, building real belvederes on the outside wall of the precinct.

### 109. Entrance to the Tower of Abu-I-Hayyay or the Queen's Dressing Room (14th century)

The following of a pattern in the composition of the entrances is a feature of Classical Times present in Nasrid architecture inherited from the rich Hispano-Muslim tradition.

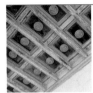

### 110. Gallery of the Queen's Dressing Room (16th century)

Detail of the coffered ceiling which covers one of the finest belvederes in the complex.

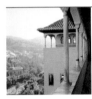

### 111. Tower and Gallery of the Queen's Dressing Room

The privileged position of the Tower of Abu-I-Hayyay caused it to be adapted for the private chambers of the Empress Isabel.

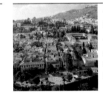

### 112-113. View of the Albaicín from the North wall of the Alhambra

The Alhambra, together with the Albaicín, constitutes a series of values in a unique structure of Medieval, architectural, urban and landscape elements.

### 114. Queen's Dressing Room

Detail of the interior decoration of the ground floor where one of the wall paintings of the Bay of Tunisia can be seen.

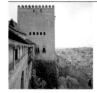

### 115. Comares Tower and galleries of the Queen's Dressing Room and the Court of the Iron Grille

The singular reciprocity – interdependence and antagonism – between the acropolis of the Alhambra and the lower city of Granada is one of its most striking features.

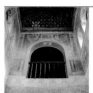

### 116. Peinador de la Reina
(Queen's Dressing Room)

Detail of the Renaissance paintings which decorate the inside of the lantern. They illustrate the rich superimposition of Christian Renaissance and Muslim medieval elements.

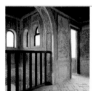

### 117. Queen's Dressing Room

Inside of the so-called Sala de la Estufa (The Stove Room). The wall paintings illustrate scenes of the landing of the troops of the Emperor Charles V in Tunisia.

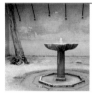

### 118. Court of the Iron Grille

Between the outside wall and the buildings of the Alhambra – the wall in the background encloses the Baths – there often appear areas like this one which contains an isolated courtyard-garden.

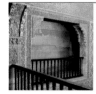

### 120. Bath of the Comares Palace
(14th century)

There are not many buildings of these characteristics left standing. In the second half of the 19th century the plasterwork was repainted in bright colours.

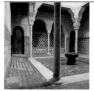

### 121. Comares Bath
### Hall of the Beds

The equivalent of the *Apoditerium* of the Roman baths, this room was a place for relaxation. Ventilation and overhead lighting were through a section of the central lantern.

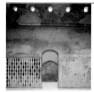

### 122-123. Comares Palace. Interior of the Steam Room of the Bath

The central room is the main room in the steam baths; below it, is the hot air heating system and it is covered by vaults with lamps in the form of stars which adjust the temperature.

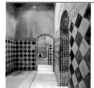

### 125. Interior of the Bath of the Comares Palace

The cold room or *Frigidarium* loses, in Islamic baths, the characteristic swimming pool of the Roman baths, which is replaced by a wash basin (in the background).

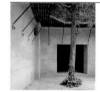

### 126. Court of the Iron Grille
(16th century)

This remote area at the foot of the Comares Tower receives the name of the great running balcony of wrought iron which encloses the upper part of the bath.

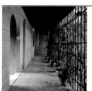

### 127. Court of the Iron Grille

Interior of the balcony which gives its name to the courtyard. On the left is the entry to the upper rooms which surround the lantern of the bath.

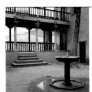

### 129. Court of the Iron Grille

The Patio is enclosed on its north side by a gallery with two floors, designed to join the Renaissance rooms of the Emperor Charles V to the Comares tower.

### 137. Pool and Maristán Lion

The two Maristán Lions are now kept in the Alhambra Museum.

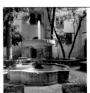

### 130-131. Fountain and Court of Lindaraja

From the 16th century the lower garden of the Palace of the Lions was enclosed by the chambers of the Emperor Charles V, and the basin of the fountain was raised in accordance with the Baroque style.

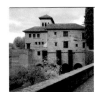

### 138-139. Morisco houses in the Partal
(16th century)

These houses were built above the main wall, superimposed on the structure of the Palace of the Partal.

### 132. Pool and Gardens of the Partal

The rooms of the Partal were distributed around a large pool; the remains of these were discovered from the early 20th century, and were incorporated into fertile gardens with other elements (such as the Maristán Lions, now kept in the Alhambra Museum).

### 140. Morisco houses in the Partal

Details of the interior of the houses with some remains of the original Nasrid decoration.

### 134. Palace of the Partal

Detail of the coffered ceiling of the upper floor, a replica of the original which was taken down at the end of the 19th century and transferred to Berlin, where it is still kept to this day.

### 135. Oratory of the Partal
(mid 14th century)

Daily prayer was often said in the Muslim palaces of the Alhambra, which had singular buildings like this one, facing the Meca.

### 141. Morisco houses in the Partal

Details of Nasrid decoration, conserved inside the houses.

### 141. Morisco houses in the Partal

Details of the interior of the houses with some remains of the original Nasrid decoration.

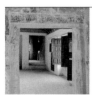

### 142. Morisco houses in the Partal

In the foreground, remains decorated with an inscription from the Nasrid period on the lintel of an inside door.

### 143. Morisco houses in the Partal

Detail of the Nasrid wall paintings depicting an expedition.

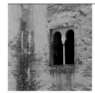

### 144. Tower of the Princesses
(end of the 14th century or beginning of the 15th century)

Outside window of one of the chambers, corresponding to the main floor.

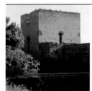

### 146. Torre del Agua
(The Water Tower)

As its name implies, this tower watched over and defended the entry of the Sultan's irrigation channel to the Alhambra. Destroyed by Napoleon's troops in 1812, it was rebuilt in the mid-20th century.

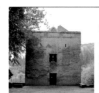

### 147. Torre de las Infantas
(Tower of the Princesses)

View of the south side, with the entrance to the royal chambers, situated on the same level,and the twin window on the upper floor.

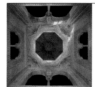

### 148. Tower of the Princesses

Inside detail of the central area, covering , in the form of a lantern, the courtyard, around which the rooms are distributed.

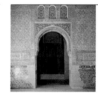

### 149. Torre de la Cautiva
(Tower of the Captive 14th century)

Inside of the main chamber, which contains one of the most striking decorative compositions in the Alhambra.

### 150-151. Tower of the Captive

Detail of the gallery which surrounds the interior courtyard.

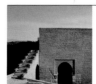

### 152. Torre de los Siete Suelos
(Tower of the Seven Floors)

Façade of the Tower and Gate, rebuilt in the mid-20th century, in the section of the Alhambra which most suffered from the explosions caused by Napoleon's troops in their retreat.

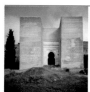

### 153. Tower of the Seven Floors
Outside Façade

This gate, rebuilt according to ancient engravings, was one of the four exterior gates of the Alhambra. It must have been built in the mid-14th century to be used as an entrance to the upper section of the precinct.

### 160-161. Gardens of the Generalife

From the fertile New Gardens of the Generalife an excellent view of the walled precinct of the Alhambra can be obtained.

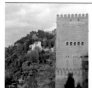

### 155. Comares Tower with the Generalife in the background

Next to the Alhambra, extending over the Cerro del Sol, and watching over the rearguard of the precinct, is the estate of the Generalife.

### 163. Portal and patio entrance to the Palace of the Generalife

The entrance and interior structure of the Palace of the Generalife is very similar to that of the palaces of the Alhambra, with two forecourts on different levels and a portal.

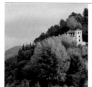

### 156. Meadow and Palace of the Generalife

The Generalife is, at the same time, a place to relax in and an agricultural estate, with several orchards for growing fruits and vegetables.

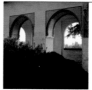

### 164. The Generalife. Gallery in the Court of the Water Channel

Perhaps one of the main changes, from the 16th century, in the Nasrid palace of the Generalife, was the opening of its central patio, through a gallery, in order to emphasise still further its value as a belvedere.

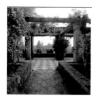

### 158. Pergola of the New Gardens of the Generalife

In the mid-20th century a large Mediterranean style garden is deployed over part of the cultivated land of the Generalife in order to join the Generalife to the visit to the Alhambra.

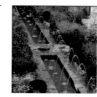

### 165. The Generalife. Court of the Water Channel

This central area of the Palace maintains its medieval, heavenly atmosphere. The fountains which surround the irrigation channel have been added recently.

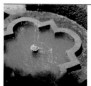

### 159. Fountain of the Lower Gardens of the Generalife

One of the most outstanding features of the Generalife is the permanent presence of elements of water and vegetation which appear in all corners of the precinct.

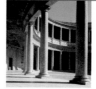

### 166. Gallery of the courtyard of the Charles V Palace

The Monumental Complex of the Alhambra, inside the Nasrid palatine city, also contains one of the most representative buildings of European Renaissance architecture.

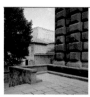

### 168. Corner of the Charles V Palace
In the background, the nasrid palaces

From 1526 Charles V had his imperial residence built next to the Islamic palaces of the Alhambra, as the image and symbol of the new Christian power.

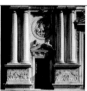

### 169. Charles V Palace
Detail of the west portal

The great portals of the Renaissance Palace stress their important symbolic role and break the horizontal line of the facades.

### 170-171. Charles V Palace
Courtyard and annulet or circular gallery

One of the great achievements of the Palace is the articulation of a circular patio (symbol of heaven) inside the square (symbol of earth) on the ground floor of the building.

### 173. Palacio de Carlos V

La articulación círculo-cuadrado se aprecia especialmente en la solución de las escaleras, como la situada en el ángulo noroeste, que fue añadida en el siglo XVII.

### 175. Patio del Palacio de Carlos V

El desarrollo horizontal de los anillos de la planta baja y alta del patio queda equilibrado por el ritmo vertical de las 32 columnas de órdenes clásicos, con sus correspondientes pilastras interiores, separadas por un bello entablamento.

**Description of the photographs**
Jesús Bermúdez López
Granada, November 1999

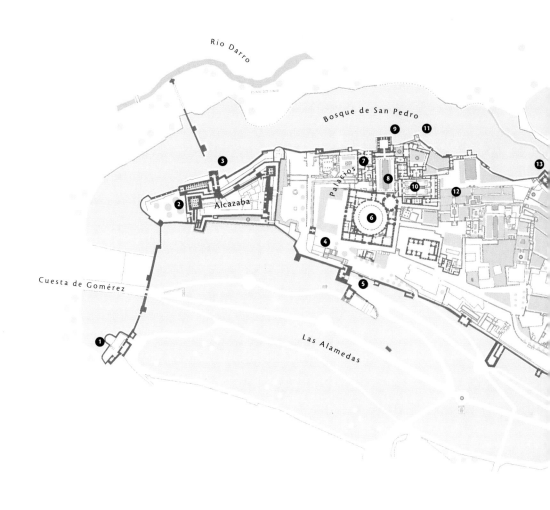

Rio Darro

Bosque de San Pedro

Cuesta de Gomérez

Alcazaba

Palacios

Las Alamedas

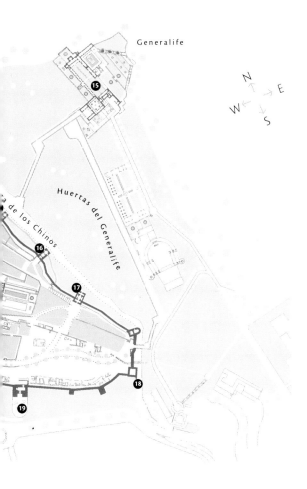

Generalife

Huertas del Generalife

de los Chinos

N
E
W
S

# Overall plan
## of the Alhambra

1- Vermilion Towers

2- Watch Tower

3- The Arms Gate.

4- The Wine Gate

5- The Justice Gate

6- Charles V Palace

7- Mexuar

8- Court of the Myrtles

9- Comares Tower

10- Court of the Lions

11- Tower of the Queen's Dressing Room

12- Partal

13- Tower of the Spikes

14- Tower of the Judge

15- Palace of the Generalife

16- Tower of the Captive

17- Tower of the Princesses

18- The Water Tower

19- Tower of the Seven Floors